The Faces of Hollywood

The Faces

South Brunswick and New York:

London: Thomas Yoseloff Ltd

of Hollywood

By Clarence Sinclair Bull

With Raymond Lee

A. S. Barnes and Company

A.S. Barnes and Co., Inc.
Cranbury, New Jersey 08512

Thomas Yoseloff Ltd
18 Charing Cross Road
London, W.C. 2, England

6844

Printed in the United States of America

Contents

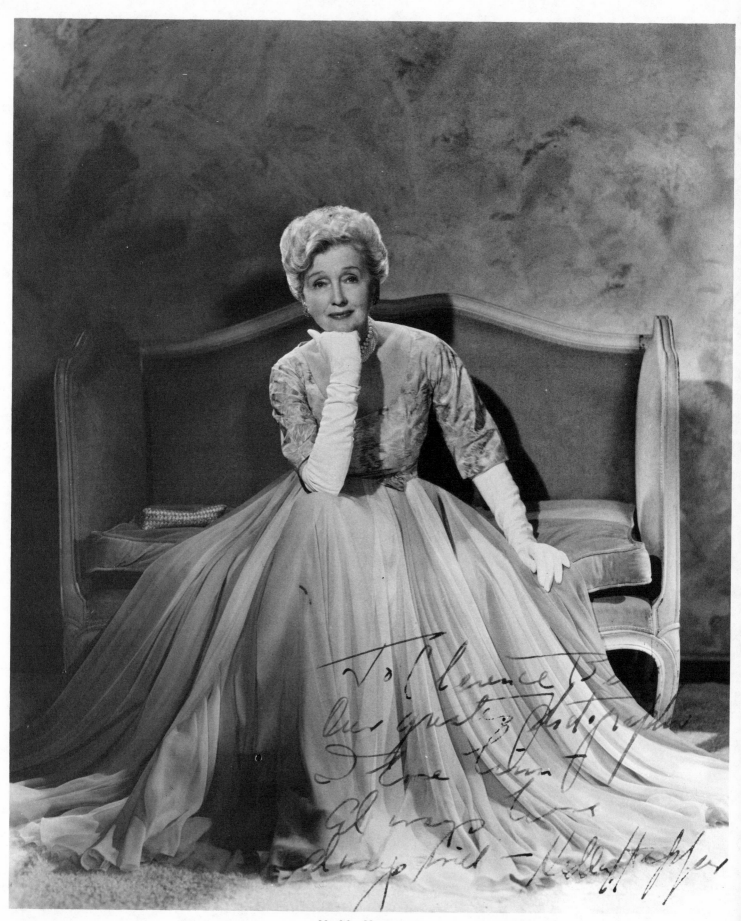

Hedda Hopper

Clarence Bull

by

Hedda Hopper*

Hollywood—First time Greta Garbo put her foot into Clarence Bull's portrait gallery at M-G-M, she posed for three hours straight without uttering one word.

So nervous was Garbo, she didn't realize that the man behind the camera was just as scared. But after that, Clarence was the only man who could take her picture.

As much of a Metro institution as Leo the Lion, Clarence shot stars for 40 years, beginning with Olive Thomas, Mabel Normand, Pauline Frederick and Geraldine Farrar.

"The first and last thing I learned about glamor," he says, "is that woman's crowning glory holds first place in her heart.

"The lipstick can be crooked, nose shiny, make-up indifferent, but let one hair be out of place and her composure is gone."

The professional photographers of America named Bull honorary master of photography, a title conferred on but one other man in our town, Charles Rosher. Clarence travels about the country speaking to photographers and criticizing their work.

Music and make-up are what he always advises for a successful glamor portrait; "Music seldom fails to put a star in the mood.

"I'll never forget the time I asked my assistant

* Reprinted through the courtesy of the Chicago Tribune-New York News Syndicate, Inc.

to get some records for a Garbo sitting. He assumed she'd like only classics. After several had been played, she quietly asked if he'd play 'Broadway Rhythm,' her favorite then.

"Amateurs should remember that wonders can be done with make-up. Thank heaven, people want to look natural again. When I started, make-up was a matter of dead white with a splash of red for a mouth, and black eyes.

"I always try for the quality of naturalness. Clark Gable would pace up and down, then think of a good story, stop to tell me, and that's when I'd click the shutter. Clark was the most natural man —no pose—just himself.

"He was one of the few who never kept me waiting. Vivien Leigh was among them. The only time she was late, she almost lost Gable as her co-star in 'Gone With the Wind.'

"Before the picture started, I was to photograph them on the famous old Southern staircase that's been used in hundreds of M-G-M pictures. Clark showed up, but no Vivien.

"After an hour and a half wait, he was madder than a hornet. 'If that's the way they do things in England, I don't want to make this picture,' he stormed.

"I tried to calm him and got hold of the man who made the appointment. He explained there'd been a mix-up and Vivien hadn't been told the right time.

"Clark said, 'O. K.,' and walked out for 10 minutes. When he came back he said, 'I still think I'll walk out of this picture with a dame like that!' But five minutes after they'd met, she wrapped him around her little finger. She really had charm. My gallery was a favorite meeting place for Vivien and Laurence Olivier."

Getting Spencer Tracy to pose was one of the toughest jobs Clarence Bull ever had. Once in desperation he asked Katharine Hepburn to help him. She called Tracy, told him she had an idea to discuss, asked him to drop by. The minute he was inside the door she locked it and he was trapped.

"I got one of the greatest portrait sittings I ever made," says Clarence.

"Judy Garland was another who was hard to locate. Bill Powell, once he got going on a sitting, stayed longer than anyone. Bob Taylor's a cinch—he's happy when you talk horses.

"I had one run-in with Hedy Lamarr, who was over critical of proofs. I got along famously with Grace Kelly, but didn't think she'd live long enough to get married. Last time I photographed her she was doing a picture with Sinatra and Crosby and preparing for her wedding as well. She was beat.

Norma Shearer had the reputation for being difficult, but that was because her so-called friends who'd look at the proofs told her they didn't do her justice.

"Luise Rainer and I were very good friends—went together for some time. She had an unfortunate experience when she first came here.

"A 'friend' got a husband and wife team to work for her. One day she showed me her grocery bills and household expenses and asked if I thought they were too high. They sure were. The servants were padding the bills and pocketing the money."

The Faces of Hollywood

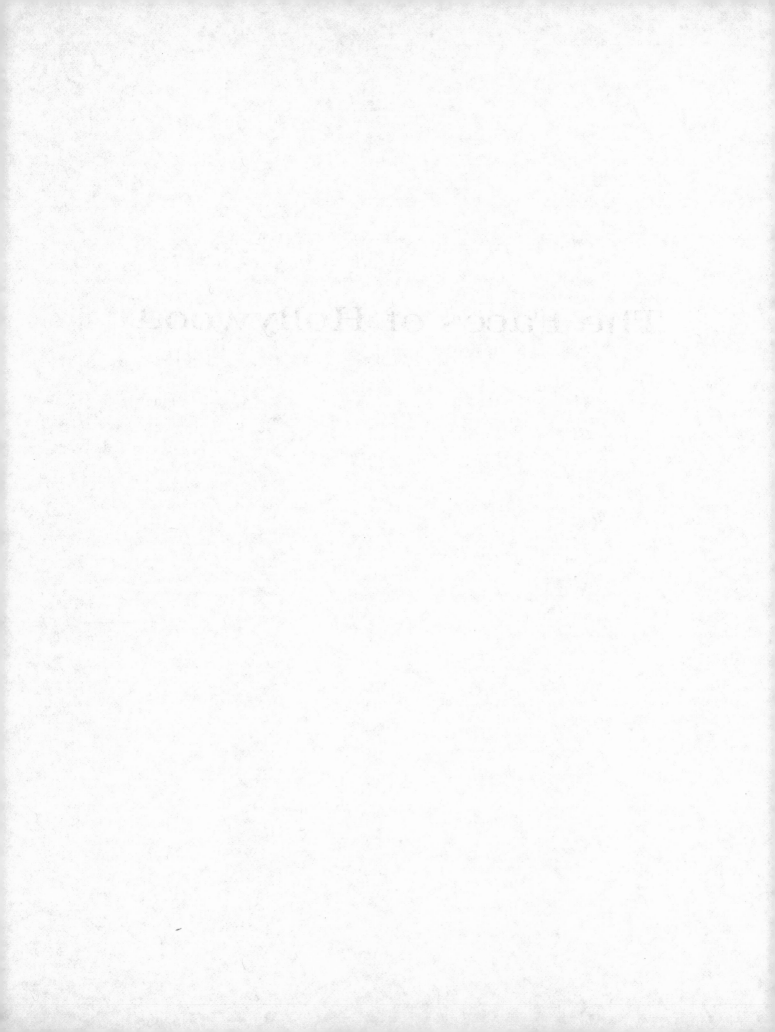

1

A Rawbone from Montana

For over forty years I have photographed Hollywood's greatest stars: Garbo, Gable, Harlow, Elizabeth Taylor, the Barrymores, to name a few.

In portraits I have tried to capture a moment or mood unattainable with the motion picture camera. I have also captured highlights in human experience that shall live with me as long as I can remember.

How did a rawbone from Montana get the artistic urge?

The year was 1912 and the town Sun River. My father as Postmaster had many friends, and among them was the world-renowned Western artist, Charles M. Russell. Following a serious illness, Charlie and his wife Nancy suggested I spend some time in his studio. Soon he was trying to teach me how to paint. My fingers were sticks. But how I thrilled watching Russell stroke a stallion or a blazing sunset on canvas!

Charles Russell was one of the most outspoken men I have ever known. One day as I picked up a brush, he gently took it from me and said, "Clarence, you're painting from your fingers. It must come from your heart. Now, I know you appreciate beauty and all that goes with it. Why don't you get yourself one of those Kodak cameras and let it exercise your fingers while you work on your heart?"

As I trudged home through a gentle snow I knew I had to get that Kodak or bust. But how?

When I told my father what Charlie had said,

he suggested I earn the money by selling the *Saturday Evening Post* to the ranch hands around the countryside.

And that was how I got my camera—on horseback selling the *Post*. On my fourteenth birthday I entered a photographic competition and won first prize. My picture showed a Montana snow storm I called "Winter's Veil."

Years later when Russell visited Will Rogers at MGM, and Will asked me to snap their picture, the great humorist said to the great painter, as I set up my camera, "You know, this maverick hails from your range."

Russell puffed on his cigarette and stared at me blankly. "Yeah, I remember him. I tried to teach him to paint, but I knew he would never amount to anything." He nudged Will in the ribs. "See, he has to use that confounded contraption to make our picture."

By the time I entered the University of Michigan I had a chance to snap something beside pretty girls —some famous names in the world headlines. Working for the *Michigan Daily*, I photographed such guests of the University as the world famous opera stars Geraldine Farrar and John McCormack, the hero Admiral Perry and the silver-tongued orator, William Jennings Bryan. All this was outdoor stuff with no flashbulbs. But everyone seemed to like what I shot. After school I did odd jobs in the camera shop.

The afternoon of the big game with Minnesota,

a newsreel cameraman parked his camera in the shop and headed for the nearest pub. By kick-off time he was rip-roaring drunk, so the owner of the shop suggested he sleep it off in the back room. But who would shoot the game? The shop owner eyed me, and then pointing to the movie camera said, "You may as well take a crack at it."

All I knew about a movie camera was to turn the crank twice every second. But I shouldered it and took off for the game.

Excited as a bronco-buster I ran out on the field with all the players and started grinding the action right and left. Once I was on my belly when some-body, missing his assignment, tackled me. Finally the referee kicked me off the gridiron as a hazard, but not before I'd gotten some exciting footage.

The next morning a sober newsreel man thanked me heartily and handed me a fifty-dollar bill. It was more money than I had ever seen in my life. And right then and there I decided if you could earn it that easily, I only had a couple of sore ribs, I'd head for Hollywood the day I graduated.

The year was 1918; the First World War was coming to an end as I boarded that train for cine-maland, and my life's labor was beginning.

2

A Moving Van with Legs

At my first job at the Metro studios in Hollywood I was listed as an assistant cameraman. I was more of a moving van on legs. I carted the head cameraman's equipment every time the notion hit him—and it hit him constantly. My back was sore at night but I loved every ache and pain because I was learning the fundamentals of shooting movies in the days of their genesis.

During production lulls I took still photos of such stars as Nazimova, Viola Dana, Anna Q. Nilsson and May Allison. I showed the prints to the publicity department and they decided to use them to exploit the Metro starts.

I was proud as Punch until some efficiency expert decided I was excess on the payroll.

But at Sam Goldwyn's film factory I was hired to do straight publicity shots after I showed them my Metro output—unposed pictures of the beloved comedienne Mabel Normand and the great stage actress Pauline Frederick. Later these photos were known as candid camera.

Pauline Frederick was my first model. Such a beautiful and dramatic face! Her eyes could tell a dozen stories. I discarded the old-fashioned quickie type of still. I took my time. I watched the changing moods of my subject and snapped the shutter as I felt the inspiration. The praise should have turned my head but I had sense enough to know perfection was an illusion and that I must keep trying and trying and trying.

One morning Norbert Lusk caught me by the coat-tails as I rushed by his office. Lusk was Goldwyn's publicity director.

"Come in for a minute, Clarence."

I wondered what I had done wrong.

Lusk seemed to sense this and smiled.

"You're doing fine, young man. Now, I've got a top assignment for you. You're going to be second cameraman on Geraldine Farrar's new picture, *The World and its Women*, co-starring her husband, Lou Tellegen."

"That's wonderful. You know, I photographed Miss Farrar when I was a student at Michigan. I hope she remembers me."

Michigan seemed a long way from Hollywood.

"Well, Clarence, first I want you to do a candid layout for a movie magazine. And for this you will be shooting Miss Farrar and another famous opera star who'll be visiting the studio tomorrow."

I remembered John McCormack and how cooperative he had been at Michigan and I smiled confidently.

"Who's the other opera star?"

Lusk spoke with a straight face.

"Mary Garden."

I gulped. As I backed out of his office I recalled all the stories about the famous feud between these dynamic divas. I had quite a few butterflies. I had to take their pictures candidly and still make them look as beautiful as nature had made them and

Pauline Frederick, Director Frank Lloyd, Clarence Bull

without making one better-looking than the other.

Suddenly Michigan didn't seem so far off.

Farrar was famous for her fiery "Carmen" and Garden for her equally fiery "Thais." Who would star in my lens?

The next day things got off famously at the start. I recalled Michigan to Miss Farrar and she actually remembered. Miss Garden thought this charming and wished me luck in my new venture.

I shot the opera stars walking arm in arm down the main street of the studio, chattering over luncheon with Sam Goldwyn, and watching Mabel Normand caper through a funny scene with a big

tear at the end of it. I even persuaded Miss Farrar to peck Miss Garden on the cheek as Lou Tellegen helped her into her Rolls Royce.

As the limousine drove off he pulled me to one side:

"You deserve the *Croix de Guerre*."

I looked at him bewildered.

"Young man, never have two such high C ladies been so pianissimo."

The following morning as I developed my negatives and watched the two beautiful women come to life I knew it would be a photo-finish, not even Santa Anita's best judges could pick either as a winner.

Geraldine was quite a highlight for me: my first

Pauline Frederick (1919)

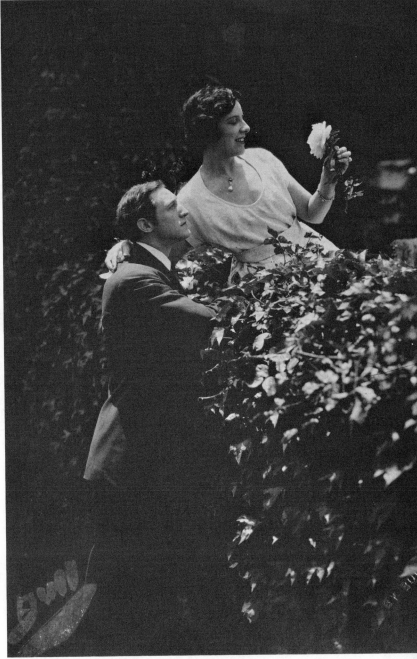

Geraldine Farrar and Lou Tellegen (1919)

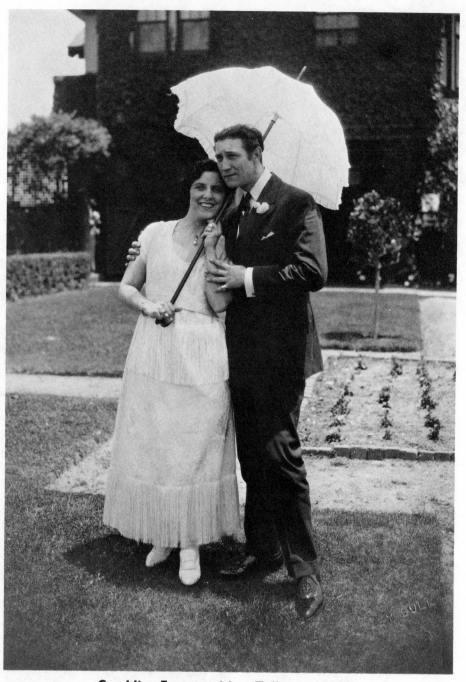

Geraldine Farrar and Lou Tellegen (1919)

big assignment and the loss of it.

The first day's shooting on *The World and Its Women* took place in a massive ballroom. Frank Lloyd, the noted director, had me grinding from a hallway across the main floor while another camera caught the action from behind the place of honor.

The action went like this:

Farrar and Tellegen move down the center flanked by ladies and gentlemen of the court and then ascend to the dais.

It was a hot morning and the set was stifling. In those days when camera equipment broke and needed repairs, it was simply taped up. "Tape it up and let's go," was the order of the moment.

Lloyd's voice boomed out—"Lights! Camera! Action!"

Everything was smooth until the stars walked in front of me. Suddenly my camera fell off and rolled smack dab onto Farrar's long train. Extras started laughing as she tugged to free herself and then, slipping, fell headlong into Tellegen's arms. It might have been a serious fall.

Joe Cohen, the production manager, rushed up to me demanding what the hell had happened. I told him the tape had melted. He cracked back: "So has your job!"

Miss Farrar came over as I was picking up my camera pieces and said she felt everything would be all right. After all, she hadn't even torn her train. Tellegen patted me on the shoulder. But I must have looked like I was walking to the gallows as I slum-shouldered off the set.

Prepared to drown my sorrows in something that evening I was startled by a call from Joe Cohen's office. Mr. Cohen wanted to see me the next morning. Later that evening another call

came from a friend who said Frank Lloyd had gone to Sam Goldwyn himself about me. In Hollywood you never knew where your friends came from—like your enemies.

Joe was all smiles when we talked the next day. He said he would start organizing a camera repair shop immediately and wanted me to supervise its formation. As I walked on air out of his office he quipped:

"Clarence, I've heard some folks are allergic even to adhesive tape."

Years later, as a top he-man star, itched his way through a sitting in my studio, I remembered Joe's admonition. I wondered if the star might be suffering from the tape that bound his ribs together from a fall in his last western. When we called the hospital, they said it was possible sure enough and to come right over.

As they say, anything can happen in movies.

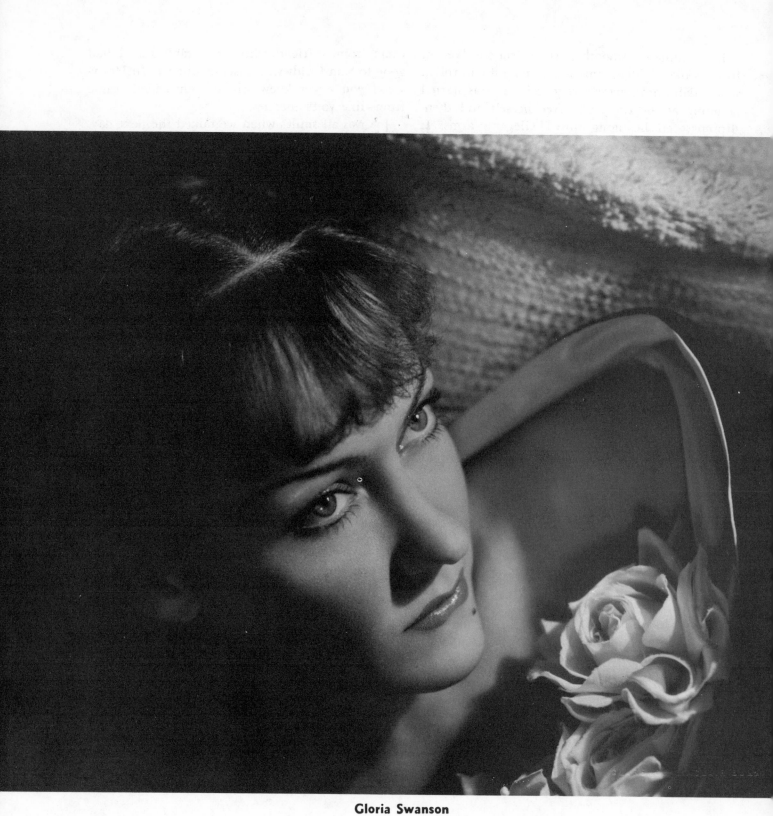

Gloria Swanson

3

Hollywood's First Movie Queen

She was the first to be titled Movie Queen. She lived the part off and on camera. No one ever saw her in curlers or slacks. To me she was one of the most beautiful and magnetic women I ever photographed. Her glory was both in her name and her reign over the silent film realm.

We all bowed to her as—Gloria Swanson.

Beginning her career with Mack Sennett as a bathing beauty with his madcap Keystone Kops, Gloria quickly decided that dramatic stardom was for her. She reached her first heights as a Cecil B. DeMille glamor girl. She stepped out of C. B.'s bathtubs to star in soul-searching drama and won the hearts of movie fans the world over.

Gloria was the first big star to break with tradition and she did it by having a baby and retaining her regal position. She ran the gamut of husbands with rugged Wallace Beery as one and a French Marquise along the line.

My fondest remembrance of La Swanson goes back to our lean days with Sam Goldwyn when both of us were struggling for recognition.

Sam had sold the studio and a strange situation plagued all the employees. New York bankers financed the productions but only on a weekly basis. Each week they sent out money having no idea what the production costs were. Many weeks there wasn't enough money to pay half of us. And more times than we cared to remember Gloria and I went to the local bank and found out the Goldwyn account had run dry.

About this time Gloria acquired a Stutz Bearcat. She wouldn't even walk a block. She had a Stutz and she'd ride to the ladies' room if there was the space.

Knowing Gloria's passion for her Stutz I suddenly was hit by a plan to defeat the payroll deficit. Gloria would wait on the corner while I rushed to the studio cashier's window and picked up both our checks. I'd race to the car and we'd race to the bank. That first race was almost to the graveyard.

Gloria weaved in and out of cars, trucks, street cars, and horse-drawn vegetable wagons as if she were back at Mack Sennett's. But we made it and got two checks cashed at the same time.

Other actors begged and offered to pay five dollars for a chance to beat the run on the bank, but Gloria shook her head and smiled a nay that would charm anybody.

Only one time did the Stutz fail us. It ran out of gas and we had to run a block to the bank. You guessed it, fresh out of cash. But Gloria had learned her lesson and always carried an extra gallon for such emergencies.

Gloria Swanson

20

4

More Stars Than There
Are in Heaven

In 1924 Metro merged with Goldwyn and my most thrilling years began as head of the still department which eventually housed the vast treasure of Metro-Goldwyn-Mayer's roster of stars.

The slogan read, "More stars than there are in heaven," and no studio in the history of motion pictures ever ran a close second to the box-office kings and queens developed at the Culver City bonanza.

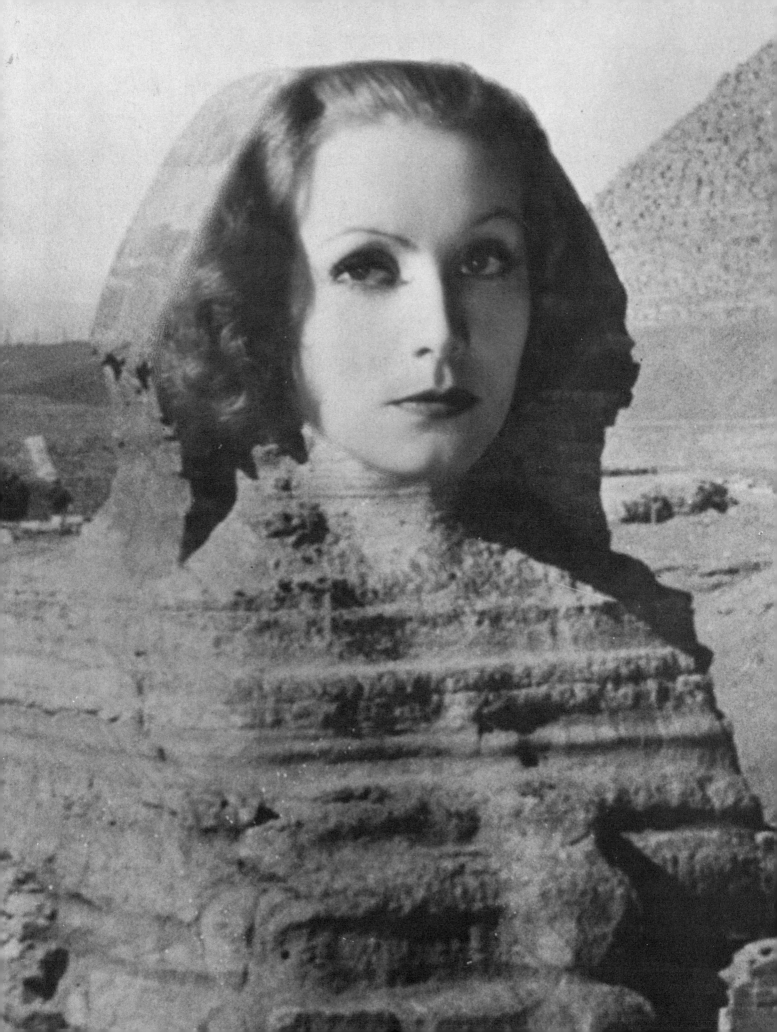

5

Mademoiselle Hamlet

I never said, "Hold it" or "still please." The face did that when it matched the inner mood. All I did was light that face and wait and watch, and when I saw the reflected mood I clicked the shutter. The face was the most inspirational I ever photographed—it belonged to Greta Garbo.

The day Garbo walked into my portrait gallery she looked like a frightened schoolgirl. What she didn't know was that I was just as scared as she. For over three hours I shot her in every pose and emotion that beautiful face could mirror. Actually I had no control over myself and I wondered when she might say she'd had too much. She said nothing so I went on shooting. Finally I ran out of film.

There had been no break. She hadn't asked for even a glass of water. As she rose and moved to the door, obviously tired yet somehow showing she had enjoyed our efforts, she said, "I was quite nervous, Mr. Bull. I'll do better next time." At the door I reached for her hand. It was as moist as mine. "So will I, Miss Garbo."

I have never worked with any star as cooperative as Garbo. She was always willing to experiment with unusual lighting. Not many stars would submit to this brutal treatment, many being afraid their bad side might show. "Their bad side" I never showed them.

I took pictures of Garbo with kerosene lamps, candles, natural lighting; and always that magnificent face triumphed against overwhelming odds.

When I began photographing her I would select the poses that I liked best to show her. One time I took 300 pictures (negatives) during a sitting. I showed her proofs on 100. She asked about the other 200. After that I showed her every pose regardless of number.

In a strange way I learned of her remarkable memory—for names, places, people, incidents, and details that few would remember.

During the production of "The Flesh and the Devil," in which Garbo played her most memorable love scenes with John Gilbert—with whom she was actually in love—an incident proved her remarkable sensitivity. (As she once remarked, "I never said I want to be alone. I said, I want to be let alone.") One of the electricians was called to the hospital where his wife was having a baby. Five years later this same electrician, working on another Garbo film, was amazed when the star came over and asked him how his little girl was doing and what her name was.

This side of the so-called Swedish sphinx was rarely revealed to the movie public. But once this lovely woman touched you with this intimacy, you could never forget it. It involved the look in her eyes, the smile on her lips, even the color of her skin, as she expressed interest in you.

When Garbo told me one morning I was to be the only lensman to take her portraits, I felt maybe Charlie Russell's advice to buy a Kodak had proven to be prophecy beyond belief.

Others had tried before me to solve the mystery

Greta Garbo as the Sphinx

Greta Garbo and Marie Dressler in "Anna Christie"

Greta Garbo

265-345

Garbo and Antonio Moreno in "The Temptress"

Garbo lighted by candlelight only

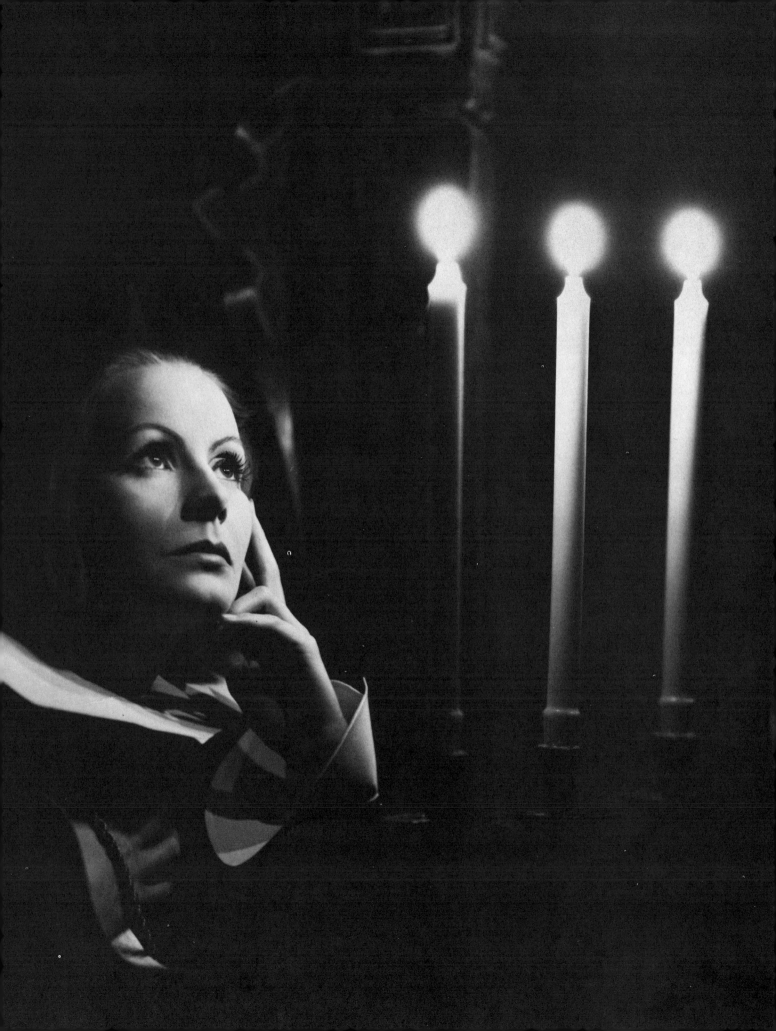

Garbo and Robert Taylor in "Camille"

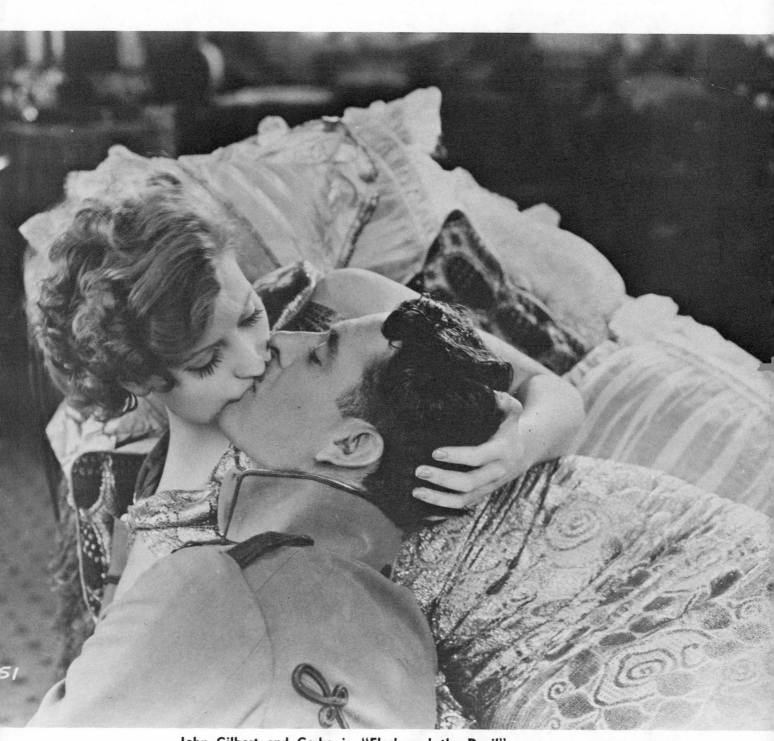

John Gilbert and Garbo in "Flesh and the Devil"

Nils Asther and Garbo in "Wild Orchids"

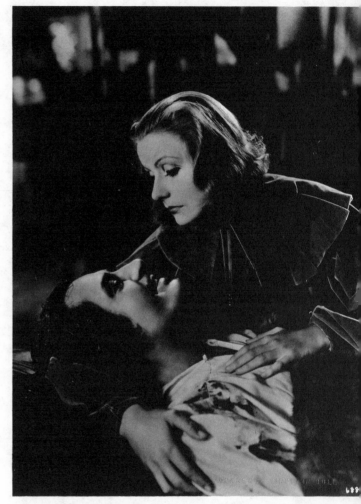

John Gilbert and Garbo in "Queen Christina"

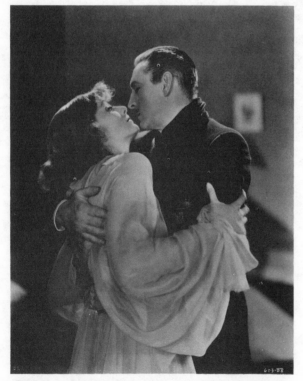

Garbo and John Barrymore in "Grand Hotel"

of that beguiling face. Maybe because I accepted it for what it was—nature's work of art—I stole secret moments even it didn't realize.

We enjoyed our work. She was the face and I was the camera. We each tried to get the best out of our equipment.

Naturally I was constantly besieged by columnists, fans and even other movie people for intimacies about this Swedish Sphinx. By the way, the world-famous photo of her head on the Egyptian Sphinx was my own creation. The first time Garbo saw it she roared with laughter and then begged my pardon, thinking she had offended me. I told her I had been afraid she might think I had offended her.

Of all the millions of words written about this complex woman few ever realized she was human. She was like everyone else. She lived on a pedestal with the world at her feet but she was as simple in her emotions and frustrations as anyone else.

I think the episode of her eyelashes will bear me out.

They were the longest I had ever seen. They created a mood all their own. If her eyes failed to tear your heart her lashes caressed with such tenderness they had you on your knees.

Everyone asked me again and again—were they real? Other stars wore false eyelashes. Were Garbo's false?

I couldn't believe they were and yet I didn't know.

When my mail brought up the question from hundreds of fans my natural curiosity would not be denied.

At the end of a long sitting I brought the camera in quite close. If they were false they would wilt under my lights now. And yet somehow I knew they weren't false. There had never been anything false between Greta Garbo and me. I felt like a silly High School boy.

I could almost hear Garbo's heartbeat. As I looked at those eyelashes reaching for the light like gossamer, I thought I heard myself say, "Are they real?"

A slow smile drifted across her mouth like a hair out of her own silken locks. The lashes fluttered and sparks of light had wings. A throaty giggle.

"What are you talking about, Clarence?"

"Are your lashes real?"

"Pull them and find out!"

And I did!

6

A Face Like a Flower

Did you ever look into the heart of a flower and see the face of a lovely girl?

That's how I saw Renee Adoree in the 1927 classic World War I epic directed by King Vidor, "The Big Parade," which also co-starred John Gilbert.

The scene where Renee hangs onto the truck taking John to the Front is unforgettable. The pathos and beauty, the tragedy and petiteness of this tiny French peasant girl who can't give up her lover, touches all ages. And when he throws her his boot and she stands hugging it as it were their baby, you know you have experienced cinema art as close to life as possible.

One day I was quite puzzled when the publicity department sent her over for a layout in the so-called Hollywood wilds. That wasn't so usual but Renee was wearing a leopard's skin. I couldn't believe they were casting her as Jane opposite Tarzan and yet . . .

Renee spoke little English and my French was limited to a couple of "oui ouis." But on our drive out to the Hollywood hills I was more than ever captivated by this delightful young woman. She enjoyed everything so much. The commonest sight excited her. She seemed on tiptoes every moment.

I shot some poses by a giant live oak near a small runaway stream. They were charming. Even a leopard skin couldn't hid the beauty of my flower.

Near a fern-dell setting I had Renee back into the shadows for a filtered shot. She looked like a vision. I loaded my camera.

About to have her strike a pose I looked down at her feet. She was standing in a patch of poison oak! I gestured. I shouted. Finally I ran over and yanked her free. I guess she thought I'd lost my mind but she just giggled as though it were part of a photographer's routine. Suddenly she began itching and scratching and she understood something was wrong as I told her we were going to the nearest hospital.

In October of 1933 I visited Renee Adoree in another hospital—a haven for those afflicted with tuberculosis. She was dying. But like a rose, smiling while the color faded before my very eyes . . .

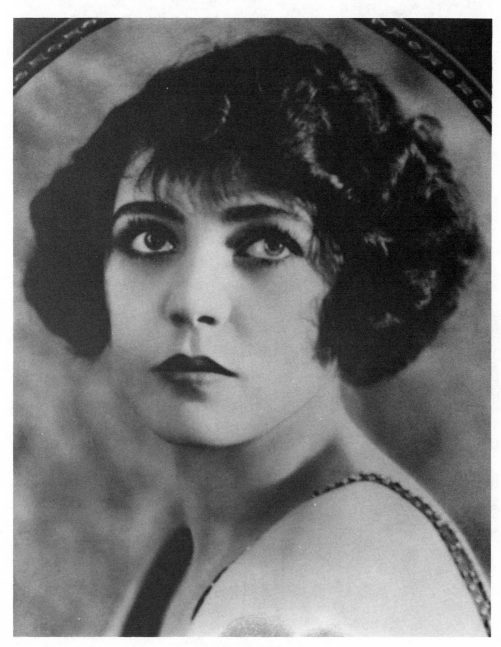

Renee Adoree

Colleen Moore

7

A Colleen Named Moore

The life of a Hollywood still photographer is jam-packed with all sorts of drama, adventure, humor and hazards. And sometimes it can be quite disarming when engendered by female stars.

In the 1923 *Flaming Youth* feature a young girl kicks over the traces and defies convention with her jazz-mad behavior. It was a hit and made a star of Colleen Moore and put a new word in our vocabulary—Flapper.

At one time Colleen was the highest paid performer, $12,500 per week, on the silent screen. From comedy to drama she rendered some of the cinema's finest portrayals.

Miss Moore was no ordinary Colleen though she looked it with her bobbed hair and piquant smile. She was not temperamental but extremely sensitive about her eyes: one was blue and the other brown. And though all films and photographs for the times were shot in black and white she expressed deep concern about this oddity in her orbs.

Another oddity: she would never pose in my studio. So I always worked with her in her home, which I did with many stars who felt more relaxed in their own environs.

One morning I suggested some shots by the pool. Colleen reclined on a chaise in a frilly gown. Trying to include as much of the picturesque background as would allow, I kept backing away from her. Suddenly I backed, camera against my chest like a life-preserver, into the pool. And with not a word of warning from the pixie-like Moore!

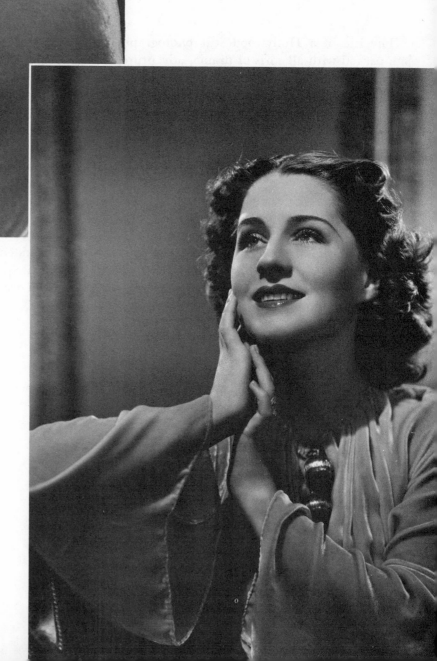

Norma Shearer

8

You Go to My Head, Norma

Another slapstick-like caper happened on the Bel-Air Golf course with Norma Shearer.

If I were asked to name my candidate for the most enduring star of the Golden Thirties I would choose Miss Shearer. Always feminine, she took both indoor and outdoor exercise with moderation. A burning ambition to reach a new peak always held her star in the film heavens.

"The wonderful tan is not for me, Clarence," she would say. "Wait until these girls reach their mid-thirties. Their skins will look like dried apples."

A man's woman all the way she could make you believe she was Shapespeare's Juliet and the rebellious girl of Adela Rogers St. John's sensational novel, *A Free Soul.*

One morning she called with a giggle at the corners of her mouth.

"Clarence, publicity wants me to do something athletic. I can't think of anything new in a bathing suit. So how about golf?"

I agreed.

She picked me up in an hour and we drove out to the Bel-Air course.

Norma tried several swings, supposedly teeing off down the fairway. She looked great. And that smile would make any score she'd card tops.

I loaded my camera and waved her into action.

Wham!

Blackout!

I came to with Norma holding my head in her lap and a group of people looking down at me as if I were a corpse.

"What hit me?," I mumbled.

"I did, Clarence, I mean, the ball did. We must get you to a doctor right away."

I felt the bump on my forehead and laughed.

"It's all in line of duty, Norma, and this one I'll remember for a long time."

Her next triumph was Marie Antoinette. Never have I seen any woman so beautiful in so tragic a role. Her playing of the young queen was simply amazing; she looked all of fifteen.

During production publicity called me to do a croquet layout. I rubbed my head gingerly as I called Norma.

"Clarence, I'm losing *my* head in this film and I don't want anything to happen to yours again! Absolutely no!"

And her majesty's command was obeyed.

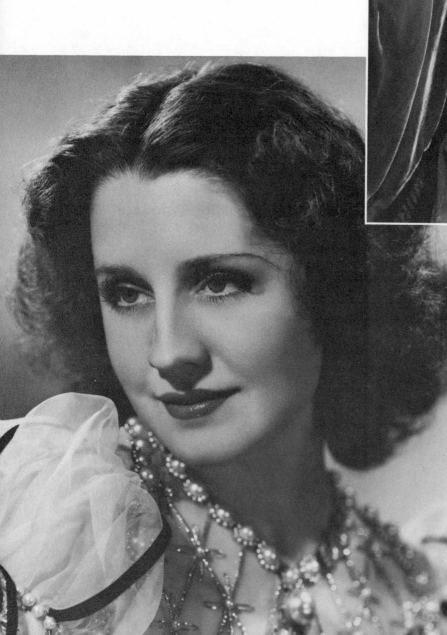

Norma Shearer

9

Queen of the Confessions

In the movie kingdom reigning stars have to be a king or queen of something—sex, comedy, westerns, something.

Constance Bennett ruled supreme in this celluloid realm. She was Queen of the Confessions.

The plots were usually based on the same theme —young girl seduced by rich pleasure-seeker, young girl left with baby, young girl suffers but triumphs over superhuman odds.

Millions of female fans shared her struggles and vicariously wished that they might have the courage for such experiences.

Overnight La Bennett replaced La Swanson as queen of the box-office. On a more personal note Bennett married Swanson's ex, a Marquis, which completed a "first" in cinema domestic relations.

In 1931 Constance Bennett starred in *The Easiest Way* at MGM, in which Clark Gable, playing a small role, caught the eyes of the producers and put his foot on the ladder.

I had heard many stories about this amazing young Bennett, who had gotten $30,000 a week from Warner Brothers while vacationing from another studio contract. She even made them pay the income tax.

I have always tried to take gossip, envy and jealousy among players with several grains of salt. Most of the stories about celebrities are generated by these three. And when meeting the object of your diatribes I have most always found the tales false or based on hearsay.

I was plenty excited when publicity arranged for a sitting with Constance Bennett.

And I was plenty taken aback when she swirled in accompanied by a maid carrying a pitcher which looked like it contained martinis.

"I hope you have refrigeration, Clarence. I'm awful at still life. And a martini does wonders for a stiff muscle."

I showed the maid to the refrigerator and then showed her out. She waited at the door looking at Bennett. Bennett looked at me. I looked at Bennett. She motioned the maid out. And in that instant our mutual respect seemed on the verge of affection.

As she sipped I snapped and what I got was quite stimulating.

Constance Bennett was the most sophisticated star I have ever known. It was neither a pose nor an act. You expected her to tell the dirty story and you laughed because from her it sounded clean. Her voice always seemed to be inviting you into the boudoir. But heaven help the man who thought he knew more about women than she knew about men.

At one of our sittings I just couldn't get the lights or background right. Constance offered me a martini. I had never indulged with a star in my studio before. But with that satin smile, who could resist?

The cocktail did relax me and the brilliant dialogue of my model was enough for three guys

like me. As I had my third martini I suddenly knew what was wrong with everything. I began shooting like mad and Bennett was smirking all over my lens.

The following morning, slightly rocky, I slowly developed the negatives with a heavy heart. Probably all a mess. To my disbelief they were good. And the prints were terrific!

Bennett howled when I showed them to her and gave me a kiss I'll remember for the rest of my life.

Her film roles in soap opera drama were a tribute to her ability to hide her inborn worldliness. Only in *Topper,* with Cary Grant as a pair of mischievous ghosts plaguing Roland Young, was her natural sophistication expressed.

Some time later with a loose schedule I began thinking about those Bennett martinis and I had to admit they did accomplish an unusual type of relaxation and contact between the photographer and his subject. But I might end up a drunk. Or a genius?

Dangling this dilemma the phone rang. Constance calling to say goodbye. She had signed with another studio. As I hung up I smiled. Never happen again. After all how many Constance Bennetts running loose in Hollywood? Besides, I'd never been a guzzler.

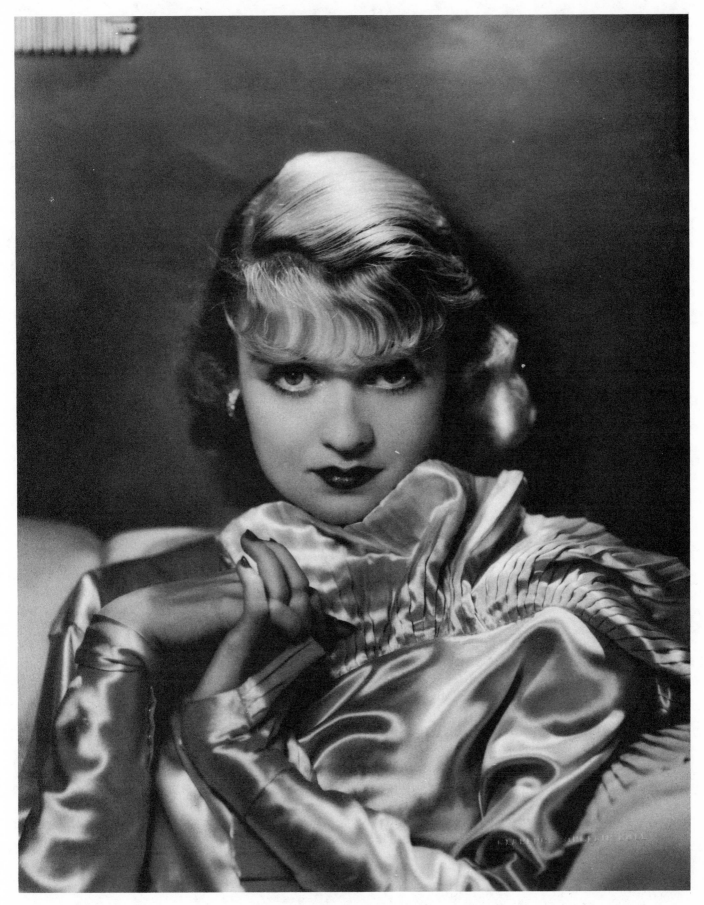

Constance Bennett

10

Prince Jack

Three days later still lingering over the Bennett binge, I answered the phone.

"Clarence Bull?"

That booming voice belonged to only one man—Hollywood's greatest actor and some said its greatest drunk continuando.

Before I could identify myself he went on.

"This is Jack Barrymore. When can we get together for some mug shots?"

We all have standout moments in our lives. And the inspiration fired by certain stars spotlighted many for me. Sometimes the utter simplicity of the experience was its finest ingredient. But truly my most varied experience came from my work with not one but three stars all with the last name of Barrymore.

John . . . Lionel . . . Ethel . . .

I name them in the order in which their magnificent faces appeared in my lens.

I had the honor of taking group shots of all three in the only picture starring them together—the 1932 epic—*Rasputin and the Empress.*

I don't think John Barrymore gave a damn about being called "The Great Profile." But I have never seen another star with one like it. I shot dozens of angles and always something new showed up in the handsome face. If a nose can be sexy, terrifying, noble, Jack's was all three and many more molded into one. And sometimes when he put his finger to it he was a clown who could pinch a smile even from the Sphinx.

But like most male stars there were times when he'd freeze up. We'd talk, swap jokes. I'd even play music. But the freeze wouldn't melt. And when this happened Jack started hamming it up and there was no ham like a Barrymore when he abandoned seriousness.

During one of these sessions he got completely out of hand like a big kid. And publicity had asked for a rush on the photos for a magazine layout.

Suddenly I remembered Constance Bennett. Ever since our meeting I always kept a pitcher of "relaxer" in my cooler. I wondered if as a last resort it might sober up Hamlet.

"Jack, how about a little drink. Sometimes it can relax a fellow sweating it out in front of this box."

The Barrymore eyes blew up like balloons and the nose quivered like a feather.

"Clarence, you shock me. I didn't know you indulged."

I felt my face redden.

"I don't. I keep it for frozen faces."

He roared until I thought the ceiling would crack.

He leapt across the room and pulling up a chair straddled it backwards.

"I know you must have heard all those horrible stories about my drunkenness."

I never saw such a picture of innocence.

"Jack, I never listen to gossip."

Jack banged me on the leg and yipped.

"I just want you to know, old chap, they are all true!"

So we have our "relaxer." And another and in

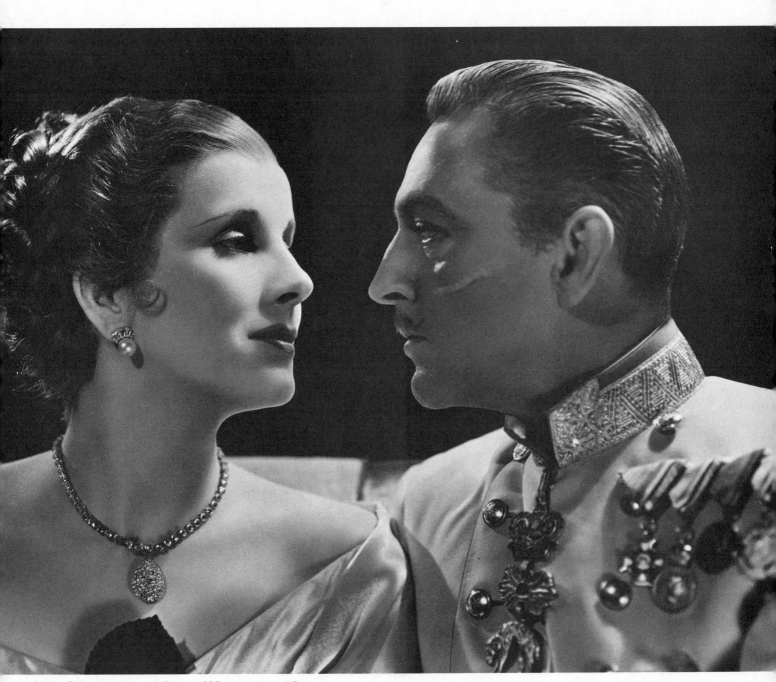

John Barrymore and Diana Wynyard in "Reunion in Vienna"

no time I was clicking my camera and Jack "still lifeing" all over my rangefinder.

Jack's wit was sharp as a razor and his humor as subtle as silk or rough as resin. He could look you in the eye with a tear on his cheek and have you laugh with a barb that ripped your ribs.

Lust for life . . . Jack Barrymore's credo, I am sure . . .

One morning he was quite late for a sitting. I always allowed him an extra hour knowing how little time meant to him. Two hours later he burst in waving the wildest contraption I had ever seen.

"Clarence, I brought you a present."

I looked dumbfounded.

"Man, you never saw a chastity belt before?"

And then he raced on telling me how he'd stumbled on the medieval protector of virginity complete with lock and key in an antique shop in Beverly Hills.

Catching the bawdy mood I suggested Jack send

43

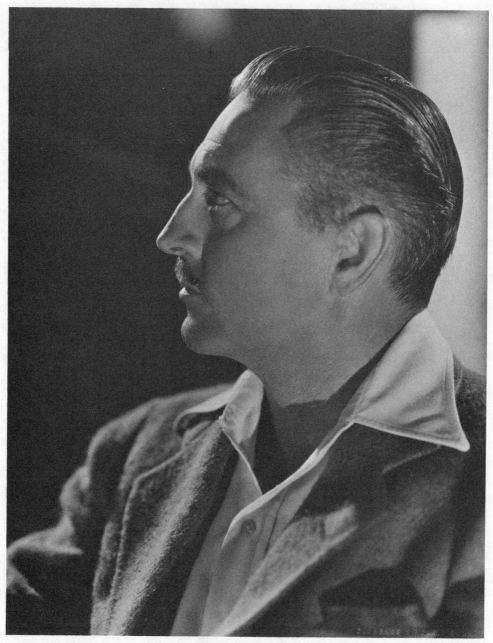

John Barrymore

it to a newly married couple in the MGM young actors' set.

Locking himself in the belt and shying around like a frightened filly he shook his head roguishly. Placing his finger to one side of his nose and batting his eyes like an owl, he falsettoed:

"I'll send it to the Madame!"

I must have looked awfully stupid.

"Madame who?"

Placing his arm around my shoulder like a father would a son, he intoned.

"Son, you coming from the free-living and free-loving state of Montana and not knowing about Madames, shakes me down to my stirrups."

Then laughing raucously he whispered the name of the lady who serviced most of Hollywood's paying panters.

I didn't see John for some time. One day he called to ask me to get some prints for a friend of his. I casually mentioned the chastity belt and if he'd had any reaction.

"Sure did, me bucko. She sent it back with a

note that read—"Appreciate your sentiments, Jon Jon, but you're twenty years too late!' "

Jack Barrymore and Douglas Fairbanks were neck-and-neck as filmland's leading pranksters. Jack once told me Doug pulled a fabulous gag he believed untoppable.

Jack was visiting Doug while he produced the silent version of *Robin Hood*. Doug told him about one of his property boys who was quite ticklish and Doug continually harassed the poor fellow by sneaking up behind him and "goosing" him at most embarrassing times. The property boy never complained since he often got an extra tenspot in his pay envelope for being a good egg.

A violinist and organist always played mood music on a Fairbanks epic. And Doug whispered that the gag involved the fiddler. Both watched as the ticklish property boy unconsciously came up and stood beside the violinist. Suddenly Doug "goosed" him and the property man leapt into the air like a screaming banshee and fell flat on the violinist, grabbing his instrument and smashing it to pieces. The stage was in an uproar.

But the violinist, usually a timid soul, went ape and started pounding on the property man. Quickly Doug and Jack separated them. The violinist was almost in tears as he bemoaned the destruction of his $5,000 instrument. The property man stared at his feet. Doug watched both as if he were innocent as a lamb, but after five minutes of this torture he finally revealed to the musician that he'd had his instrument replaced with one of lesser value. It had all been just a joke. The musician stared at Doug and then turned and walked off the set. Barrymore almost cracked a rib as Doug began bemoaning the loss of his favorite stringer.

Photographing Jack in his palatial Tower Road mansion a lady fan magazine writer appeared for an interview Jack had forgotten about.

As I set things up Jack started talking about his early life, his favorite topic. I had heard him tell the story so many different ways I wondered if any of the versions were true. The lady writer was entranced.

I asked Jack to take a position in front of the camera. As he passed me he whispered in a rather loud voice:

"Clarence, if I tell that story once more I'll believe it meself!"

Jumping to her feet the lady writer stalked over. "I overheard that, Mr. Barrymore. I have also heard many unsavory things about you, which I didn't want to believe. I came for an exclusive and you make fun of me with a rehash. Goodday, sir!"

Swiftly a gesturing arm swathed her, whirling her within an inch of the Great Profile. I can't remember what he said; maybe it was what he didn't say. But soon the lady writer was back on the sofa glowing and goggle-eyed and sincerely believing that Mr. Barrymore was just having his usual joke with his photographer.

Well, she got an exclusive all right. Jack Barrymore never spoke of his early life again to anyone.

As I raised an eyebrow to the best eyebrow-raiser of them all, he recited, "And after all, what is a lie? 'Tis but the truth in masquerade."

"I didn't know you wrote poetry."

"I don't, that's not Barrymore, that's Byron."

At the close of nearly every production special stills are shot for poster artists to work from. The advertising departments then make up the posters from these sets. Actual scenes are duplicated as much as possible.

A poster session for Jack and the beautiful British star, Diana Wynyard, playing in the satiric comedy, *Reunion in Vienna*, had me on a boudoir-set as the day's shooting ended.

John was quite gay and as he and Diana each enjoyed a miniature cigar, I set up my equipment. The miniature cigar in Diana's lovely mouth stopped me for a moment but I guessed anything could happen in Vienna. Later I learned it was the ravishing lady's favorite smoke.

We decided the action would start with Jack carrying Diana to a chaise for a romantic embrace. As Jack lifted her he grimaced. I couldn't believe she weighed that much. Had Jack been imbibing? Of course you never can tell what's packed away in a corset.

We rehearsed it several times but both of them looked awkward.

I mentioned this and both of them giggled. Jack excused himself and went off into the shadows. I hoped if he was going for a relaxer it wouldn't relax him too much.

The lights were ready and everyone was in place. Jack picked up Diana and rapture enveloped them. He was to take one step to the chaise and then on

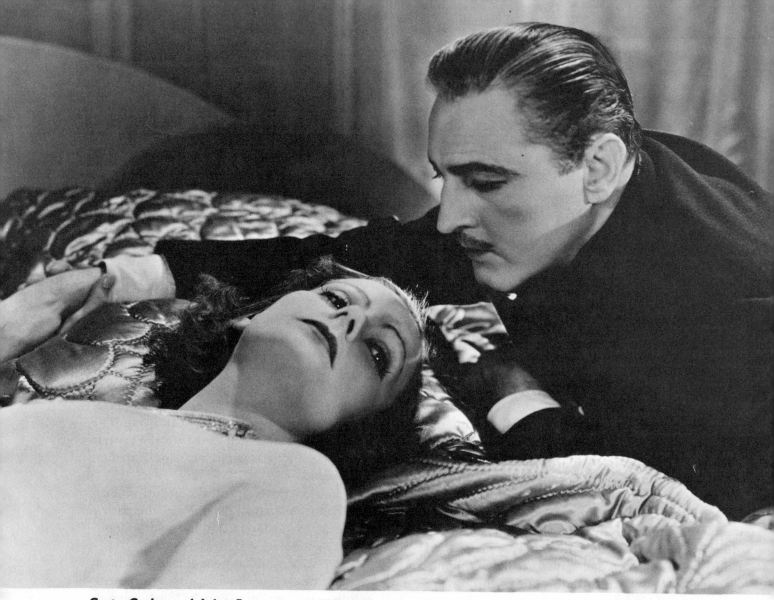

Greta Garbo and John Barrymore in "Grand Hotel"

the chaise embrace her passionately.

I began shooting. On the third shot Jack's feet slipped from under him and he whirled in a half circle and headed for the camera with Diana's head centered on the lens. Suddenly he jerked her up and her legs hit the camera's legs and then we all went down in a crashing heap.

Guffaws and giggles proved no one had any broken bones.

As we all stood up and recovered ourselves I realized Jack had been imbibing. I suggested we try again when the stars weren't exhausted from a hard day's work. As they left the stage I went over

to the chaise and to my surprise I found what had caused Jack to slip—a piece of chalk which had been used to mark the furniture. I felt my embarrassment down to my shoe-tops.

The next morning as I developed my negatives and made prints I couldn't help from laughing. I had clicked just as the fall began. The stars looked like they were loaded with champagne and waltzing to their heart's delight.

After I showed them to Jack and Diana they agreed to send them in and see what happened. They were promptly accepted.

A sad footnote. Years later dialogue written in chalk on a blackboard behind the camera was John Barrymore's tragic reminder he was relaxing too much even for his fantastic memory.

11

A Lion of a Man

Lionel, diminutive of Leon, from Greek Leo, the Lion. And Lionel Barrymore was that, a lion in so many fields of talent—acting, music, painting, directing.

Of all the Barrymores I knew Lionel the best and over the longest span. He was such a simple subject to photograph you forgot how complex the man behind the face was.

The sitting always started with us talking about art and music and then when I saw the expression I wanted, Lionel looked at me and I looked at him and we had it. Sometimes he would doze off while I was re-loading or changing the lights, but the second I said "Ready, Lionel," the eyes opened, the face quickly reflecting the mood. It seemed mechanical but it was the great actor's marvelous control and training.

His knowledge of musical history amazed everyone and most of all George Snyder, librarian for MGM's research in that department. Many times when George was stuck for information he'd call Lionel and sure enough, he'd get the facts.

Lionel rarely used makeup for disguise or characterization. He lived his part. When he left the scene to go home the character he was portraying went with him.

For me his most memorable performance was in *Grand Hotel*, the screen adaptation of Vicki Baum's hit novel in which brother John, Garbo,

Joan Crawford, and Wally Beery vied for honors. But it was Lionel as the simple tragic little accountant, Otto Kringolein, who was dying and wanted a last fling in the world of the fabled Hotel, who stole the picture. He always said it was his favorite role.

One day while watching a dance number for the first hit musical of 1929, *The Broadway Melody,* a little bent old man jogged up to me and tugged at my sleeve. I didn't pay attention since my eyes were glued on the lovely creatures capering before me. Finally a cracked voice reached me.

"Sir, I don't want to be a bother. But I need lunch money. You see, this is my first job in more than a year. Once I was a star, now I'm just an extra. But I'm happy for anything they give me."

Without looking I handed the old fellow a dollar or more in change. The story was old and new but always worth a touch.

"Thank you, sir." But as he turned and hobbled away I heard a familiar voice say, "Never thought he could be fooled that easily."

I crossed over to him and gently pulled him around.

It was Lionel Barrymore.

"What are you doing here, you rascal?"

He chuckled and straightened up.

"Same thing you are. Watching the pretty girls. Over on my set I'm directing Ruth Chatterton in

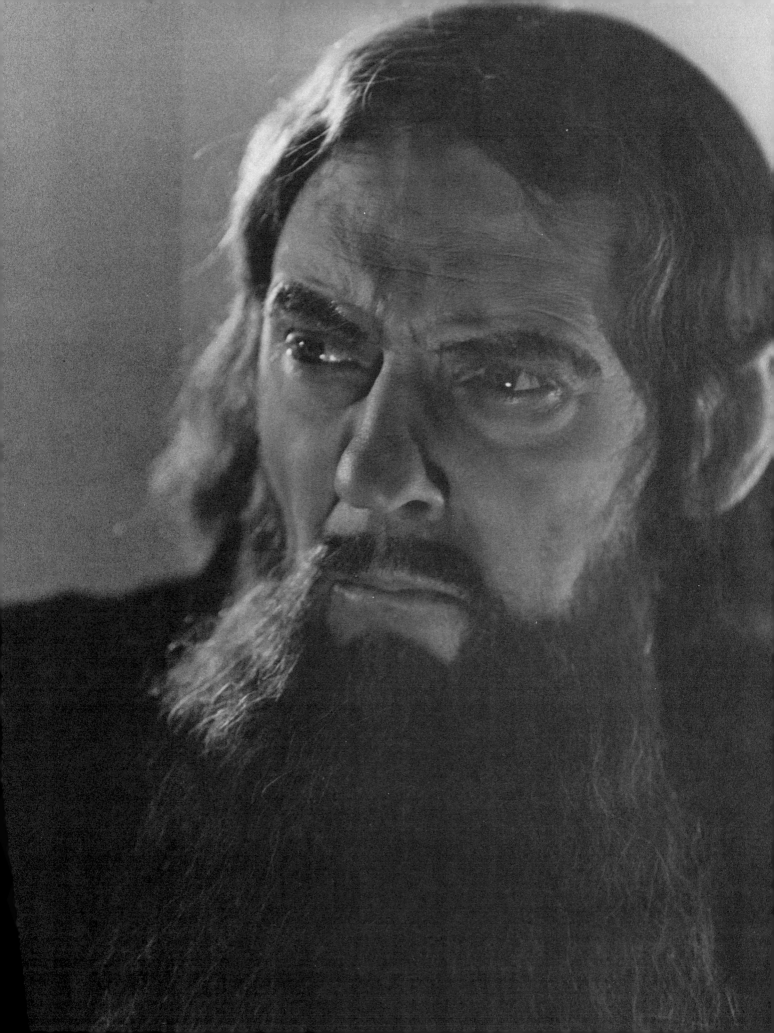

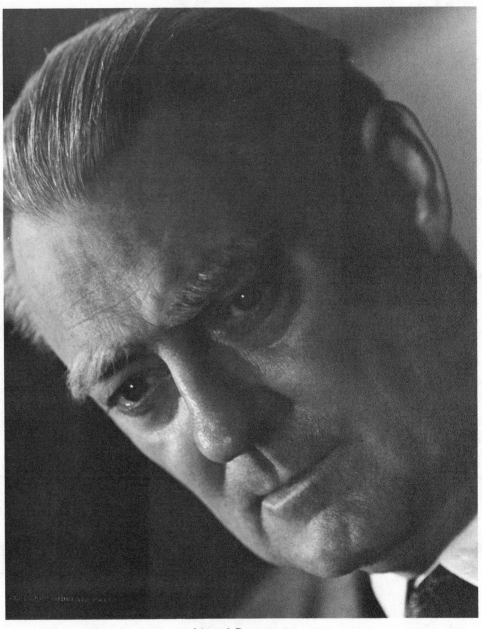

Lionel Barrymore

Madame X, only heavy drama. Even a director needs a change of pace. Now, about having lunch on your offering?"

When crippling arthritis struck Lionel Barrymore everyone thought the lion at last had been caged. Everyone but the lion himself. Despite severe pain, his performances in the Dr. Kildare series, opposite Lew Ayres as the irascible Dr. Gillespie, opened another dimension in his skyward career.

About this time he became interested in photography. It gave him another exciting out for his creativity. But he never seemed satisfied and though I encouraged him his life ended before he realized all he had hoped to from the art of the lens.

Though confined to a wheel chair he could safely drive his car once helped into the driver's seat. I can still hear him tooting his horn in front of my studio. I always ran out and helped him into his chair.

One time I was developing some negatives on a rush job and didn't hear the horn. Suddenly there was a loud pounding on my door. An irate assistant

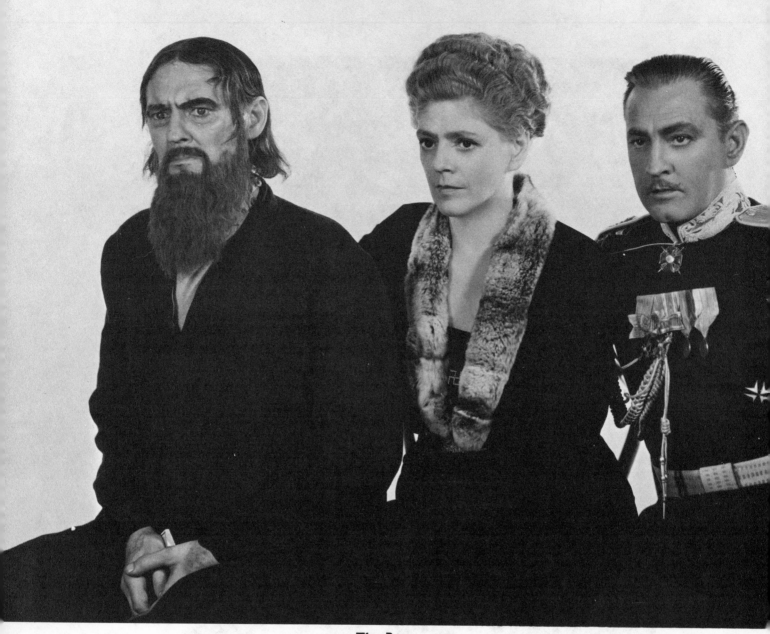

The Barrymores

director was complaining about the horn-tooting.

I glared at Lionel in his car, grinning from ear to ear.

"That old man says you instructed him to toot his horn when he comes to deliver his prints. Don't you realize you just ruined an expensive take?"

I tried to imitate Lionel in all his lionism as I boomed back at the young man.

"That old man happens to be Lionel Barrymore and L. B. Mayer instructed him to toot his horn any time he wants to be helped out of his car. You see, he's crippled with arthritis!"

As we both helped "Dr. Gillespie" out of his car, he cracked:

"The common walk is a privilege few of us appreciate until our bones run out of fuel . . ."

12

Queen of a Royal Family

I have been asked dozens of times what I considered the most photographed and revered face in theatrical annals. It seemed like a difficult question. In my lecture tours across country, stopovers in little theatres, talks with talent managers in their offices, visits with friends and photography experts there is one face I have always seen on the wall—Ethel Barrymore.

As Billie Burke explained it before I met the great lady, "You don't love and admire Ethel Barrymore, you worship her."

My first meeting with her awesomeness took place during the filming of *Rasputin and the Empress*. To say I was in a state of something waiting for her to arrive was putting it mildly. I had heard so much about her. I had thrilled to her stage performances. I had talked with Jack and Lionel about her. And yet I didn't really know her. As she swept into my studio smiling and said:

"Lionel tells me you make old faces new. I hope I won't give you too much trouble."

I grinned.

"And now, Clarence," she settled down in a big chair, her intimacy disarming me like magic, "I have only one request. See these lines in my face." We were almost nose to nose and there was the remarkable likeness to brother John. "I've spent many years getting these lines so I don't want them erased. Tell your retouchers to leave all the good ones."

I gulped.

"I know what you're thinking. I'll let you be the best judge of what lines are good or bad. Now, let's get started."

Soft lighting was best for her face both on the screen and for portraits. Some back and top lighting was needed to bring out the texture of her hair.

As to the lines in her face, they were the most complimentary I have ever seen. I tried hard to find a fault in one but finally gave up realizing that Ethel Barrymore had been pulling my leg that first day we met.

My last photographs of Miss Barrymore would be taken in her dressing room. In spite of the cramped working area she insisted we work there. When I mentioned a plush set on a nearby stage she said:

"Clarence, this is the most beautiful dressing room I ever had. I want them here. I suppose you know this was once my dear friend Katharine Hepburn's?"

Miss Barrymore had brought her own piano and furniture covers. The covers were much laundered; they were faded chintz, pale green with magnolia flowers. I can still see her beautiful hands caressing them, giving them a lustre they really didn't have. Later Katharine Hepburn told me she carried them everywhere as though they were priceless heirlooms.

There was quite a to-do when the studio interior

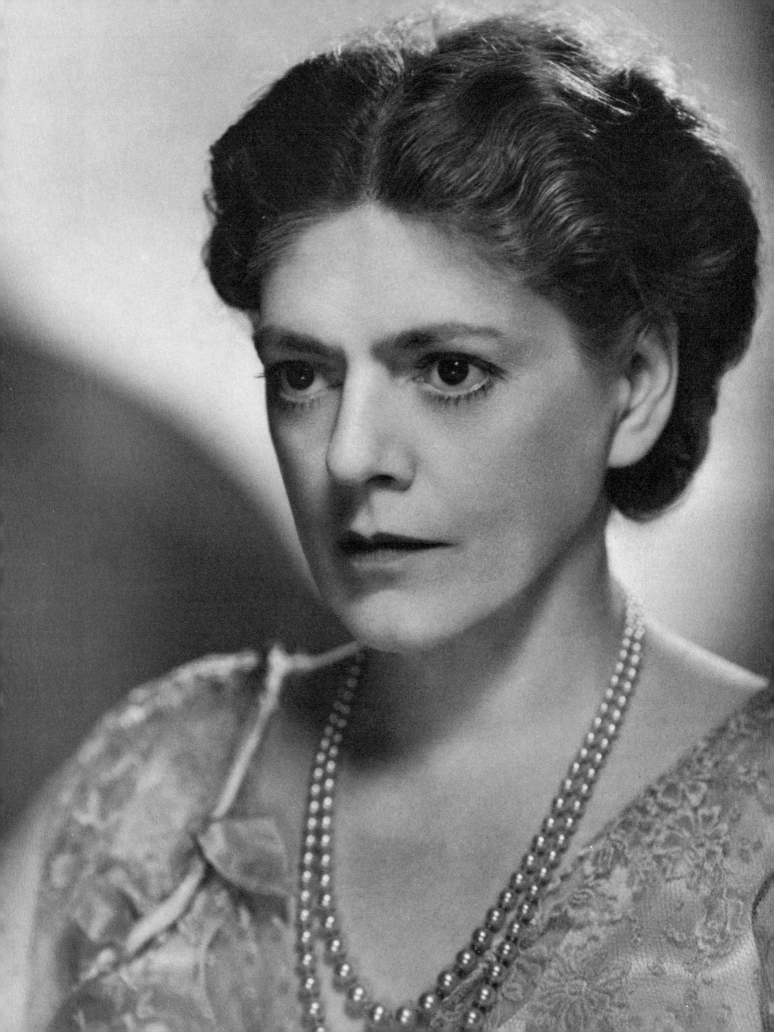

decorator met Miss Barrymore to discuss redoing the dressing room. He almost fainted when he saw the chintz covers and the piano. Miss Barrymore rejected all his suggestions and said she liked things just as they were. And they stayed just as they were and when Ethel Barrymore left the studio the covers and piano went with her.

Her stay at MGM had not been a happy one. Ethel's role as the empress was subordinate to John and Lionel's. She didn't mind this because Ethel Barrymore could just sit in a scene and dominate it without saying a word or lifting a hand.

Her biggest quarrel concerned several scenes in the story which she felt might induce libel suits. She had known the Royal Russian family and living heirs had their privacy to be protected. Despite her warnings the scenes were done and Miss Barrymore was accused of undue meddling.

The film had its world premiere late in 1932 and in 1934 England's most famous lawyer-playwright, Sir Patrick Hastings, won a damage suit for $125,000 in a London Court for the Princess Irina Alexandrovna, a member of the Royal Family. In the picture Rasputin reportedly seduced the Princess, which she claimed was not the truth.

Maybe the MGM legal department had forgotten that one of Ethel Barrymore's most dynamic roles was playing Portia in Shakespeare's *Merchant of Venice*.

There were many wonderful moments with the Barrymores. But none had the strange and haunting quality of the day I photographed the three of them together.

I was damned nervous. Jack and Lionel were personal friends. Ethel I felt appreciated me professionally. But how do you make the three most famous actors in the world *all* look good in one still?

I must confess I had a little relaxer before I went on the stage. The photos were to be taken in costume and the stage had been cleared.

The three principals walked forward and took their places. I made a few suggestions. They nodded, smiled, agreed. The silence was deafening. Not a joke or quip. Just three faces looking at me.

Then as I looked at them through my camera I got the shock of my life! They all looked alike! The amazing bond between them was frightening.

I shifted their positions. I had Lionel sitting beside Ethel. John standing. Ethel and John standing. Lionel sitting. All standing. All looked alike no matter how I posed them.

I searched their faces for help.

Blanks!

My relaxer had sweated away.

I began shooting.

When it was all over they came forward and graciously thanked me, shook my hand, appreciated my patience with them. It was like a scene in a movie.

I had expected a scene but not that kind of scene.

At the stage door all three turned and smiled and all three looked exactly alike.

But when the prints lay before me I saw only Rasputin, the evil monk, the weak and beautiful Empress, and the dashing Prince who had helped kill the supposed Holy Healer.

Oh, those mad Barrymores! They'd been playing games with me right before my own éyes and I hadn't had the sense to enjoy them.

13

Face 1001

In the Twenties Lon Chaney shocked the film fans of the world as "The Hunchback of Notre Dame" and "The Phantom of the Opera," taking his biggest step to a pedestal among the silent cinema immortals and the title of "Man of a Thousand Faces."

His genius was not in shock alone. When first flashed on the screen the monster revolted and even drew screams from the audience. But as his inner suffering, his struggle against his physical ugliness, and his agonizing labor to overcome the curse of mankind unreeled, the fans began to pity and then endure the horrible sweat of body and soul.

Here Lon Chaney won his most fascinating tribute as an actor—sympathy for the deformed and misbegotten.

Born of deaf-mute parents, Chaney's pantomime was the most dynamic on film and the key to his deep understanding and love for "those out of shape."

In 1924 Lon signed with the young MGM company and starred in *He Who Gets Slapped,* the story of a clown who gets laughs being slapped. Norma Shearer and John Gilbert were the lovers of the tragic story that found "HE" hopelessly in love with the young girl.

One afternoon Lon dropped into my studio and the chat ended up with a discussion about make-up and the importance of lighting on grease-paint and putty. He never stopped experimenting and de-

manding the best in every character he created. As we talked and the light began doing strange things to his clown-face, I took off my glasses and wiped them.

Suddenly in the gentle criss-cross of the late shadows I was startled by another face . . . The Christ . . . the lines around the mouth being drawn down by the nails of the cross . . . the lips sagging with drops of blood . . . the eyes reaching out into a space terrifying in its infinity . . .

My hands trembled as I put my glasses on again.

"Clarence, you catching a cold? You look pretty pale."

Lon Chaney was the kindest man you'd ever know. He was finger-tip sensitive to every emotion whether inside or out. He could read thoughts as easily as lips.

I coughed a couple of times and then stood up stretching.

"Lon," I stared at him hoping to steady my jumpy nerves, "sitting here talking with you I just saw Christ's face emerge from behind your clown makeup."

In those silent days this was the most silent I ever had known.

"Lon, believe me I saw it!"

Lon rose slowly and moved to the window. He looked into the street for the longest moment I ever remembered. Then he turned and spoke so quietly I had to strain to hear him.

"Clarence, as a little boy I remember a picture of Christ which used to hang in my mother's bedroom. Just the Head on the Cross. I'd study it for hours, watch what the light did to it, what the shadows tried to outdo. And sometimes the thought startled me like a voice—"Someday, Lon, if you're a really good boy, maybe your face will be remembered a little like His.'"

He sat down again and beads of sweat were pocking his white makeup.

The telephone rang and rang and Lon's voice threaded the rings together.

"I felt ashamed as if I had blasphemed. But every time I waited on my invalid mother and glanced up at the picture it seemed to say the same thing. And one time I finally told mother, with my fingers of course. And she told me back, 'We all wear Christ's face, Lon, only sometimes it takes us a lifetime to see it!' "

I answered the phone. It was for Lon. They wanted him on the set. We made an appointment for the following Monday. I watched the clown sag into the shadows outside and I wondered. Would he let me someday take his portrait as Christ . . .?"

At the next sitting I completed my advance stills for "HE" and just as Lon was leaving he said gently, "Clarence, I know you are a pretty sensitive yet level-headed fellow. I've been thinking about what happened last week. I've even been working on the make-up. Do you think it would be out of line for the monster to pose as Christ?"

Tears welled up in my eyes as I put my arm around Lon Chaney and replied, "They tell us He's in all of us. Some of us find Him in strange ways. You name the day."

That day Lon was extremely nervous. He had decided to make-up in my studio. He wanted no one to know what he was doing. I cancelled all appointments and locked the front door. I set up my camera and waited.

Slowly a figure walked out of the shadows and into my lens. In the shadows it could have been any man. As I switched on the lights it was the Christ who suffered little children to come unto Him . . .

The next day Lon and I looked at the prints. They were incredible!

Lon smiled. A rare thing to see a smile on those lips which generally showed only sneers and fangs. It seemed a fulfillment of something.

Lon Chaney and I were in another world for that suspended moment.

One of the louder voices from the publicity department burst into my studio. I'd forgotten to lock the door.

"What's new boys? Lon, cooking up another shocker? I don't know how you keep topping 'em. What's this?"

He grabbed the print from Lon and stared at it.

"Hey, fellows, we aren't hard up for material, are we?"

Lon's fists clenched.

"Say, who posed for this? A new contract player trying to be different, huh? Well, kind of a new slant. But I don't think the public will ever buy the Bible."

I took the print out of his hands.

"It's something I was working on with a friend. Just an experiment. He's never been in pictures."

"Mind if I use your phone, Clarence?"

Lon and I just looked at each other as the voice rattled on.

The photos were never shown to anyone. Lon even suggested I destroy them. But somehow I couldn't do it. The publicity man's crude comments had done something to Lon. Before he left he said, "We had our moment; that no one can take from us. Thanks for everything, Clarence."

I put the photos in a dead file that only I knew about. The years passed and Lon and I had many exciting sessions, but the Christ image was never mentioned.

Time was a deceiver in those golden days when sound was poking its tongue onto the silent screen and everyone treated it like a naughty boy. But there was a tradition, and one of the most enduring came every Christmas. We all chipped in and teams went around with baskets and presents to our fellows who didn't have it so fortunate.

I'll never know why I went to the dead file that Christmas week. As I looked through it I realized the Christ photos were missing. I searched every possible file. The Chaney stills were gone. There had been improvements in the building; the files had been moved many times and I had employed various assistants. But no one had access to those files. I had the key!

At the Christmas studio party, also a tradition, I could hardly look at Lon. He wasn't a party man and stayed just for greetings. Watching him leave

Lon Chaney

I had a strange feeling I couldn't define. "God Bless Ye Merry Men" sung by the imbibing studio personnel didn't cheer me any.

I can't remember who I made the Christmas rounds with. I know there were three of us and we had a prepared list of people to visit. As we went from house to house my spirits rose at the smiles we brought to surprised faces. It was warm in Los Angeles that Christmas Eve, a sharp contrast to the Montana yuletides I had been born to.

Our last basket . . . a small frame house deep on a narrow lot, a few eucalyptus trees trying to hide its size. We churned up dust as we drove up . . . a faint light through the windows . . .

I knocked at the door. I could hear the knock repeated inside. I tapped again. The door opened and a boy of ten with a girl of five behind him stared at me.

"Merry Christmas," we all chimed.

"Merry Christmas," the little ones repeated.

A young woman out of the gloom. I thought she would cry as we handed her the things but the

smiles on the faces of the children stopped her tears.

A branch of a eucalyptus tree nailed to a piece of wood pitifully mimicked the yule tree in the center of the wooden table. Pieces of colored paper and bits of tin-foil brightened its austerity. At the base was a smattering of cotton. But there were no presents underneath this bare tree.

Gradually there was movement within the gloom, and my eyes focused on a red vigil light wavering on the mantlepiece. As my eyes rose I saw the outlines of a picture on the wall. Slowly I was drawn to it.

The young mother saw me staring at the vigil light and started talking in broken English and gesturing to the mantle. The boy came up and taking her hand said in very good English, "My mother is trying to tell you, sir, how much she thanks you and your friends for your gifts. But most of all she wants you to know she knew we would have a good Christmas because of the Holy picture."

I stepped up to the picture.

"You see, sir, my papa, before he was hurt in the accident brought it home and said it would always protect us, always as long as we believed."

Slowly the red circle of light outlined the face. Lon's face . . . Christ's face . . . the red flickering almost moving the mouth . . . lowering the lids . . .

I couldn't believe it!

My companions were suggesting it was time to leave.

I touched the little boy's head.

"Where did your father get this picture?"

"He used to work at the movie studios and one day in the trash can he found this picture of Our Lord. And he said it was the most beautiful he had ever seen and he knew it was a sign to find such a picture."

No sound was heard in the room as I asked: "Where is your father now, son?"

He smiled: "In heaven, sir, with Our Lord" . . .

The following year was a busy and revolutionary one for the motion picture world—1930. Pictures talked! Sound had arrived. Silence was dead. Confusion reigned. My beloved stars crowded my studio in "Bull Sessions" mouting almost to hysteria as they wondered how their voices would sound.

In this year, Lon Chaney the next-to-the last holdout against sound at the studio (Charlie Chaplin was the last,) finally remade one of his classic silent hits, *The Unholy Three*. It scored a tremendous success. Lon played a ventriloquist who masqueraded as an old lady and utilized four different voices in his nefarious activities as a crook.

A brighter star was rising for Lon Chaney.

I had seen Lon infrequently that year. Always there was something crowding our lives apart. Someday I would have to tell him about that Christmas Eve.

Dracula was next on his list and he was giving this fabulous monster all the experience of his many years of scaring the daylights out of movie fans.

The publicity department called me about *Dracula* and I called Lon. We made an appointment for the following week. It was an appointment Lon Chaney never kept. I waited for almost two hours and then left the studio.

The next day I heard he was ill at home. He had been unwell for some time. He was suffering when I had talked to him and yet he had hoped to make the sitting.

On August 26, 1930, Lon Chaney died of cancer of the throat. He had spoken only once on the sound screen and a new horizon had lain before him.

If only I had been able to tell him about that Christmas Eve.

But he had sworn me to secrecy and maybe someone higher up had heard our pact.

14

Angel Face and Angel Voice

Many film folk have said I have been all things to most of the screen's favorites. Well, that's a large order. I know I have tried to be their friend, sometimes a counsellor, and always a perfectionist as far as preserving their cinema image.

But I presume that out of all the experiences I've had through the years the way in which I discovered Jeanette MacDonald's almost tragic weakness was the most unique.

Jeanette and Nelson Eddy reigned as the singing lovers in both the Thirties and the Forties.

Jeanette's delicate beauty and feminine grace and exquisite manner were as much a joy to photograph as her voice was to record on the sound track. No one looked as breathtaking in color as the star of such hits as *Naughty Marietta, Maytime,* and *New Moon.*

Waxing poetic for a color sitting I prepared a bower of lilies of the valley and delphinium to background her loveliness. As Jeanette waltzed into my studio humming a tune from *The Firefly* and saw the flowers she kissed me on the cheek to express her delight.

As I began arranging the lights Bob Leonard, who directed many MGM hits and some of Jeanette's, dropped in to see some proofs.

Jeanette relaxed on a wooden bench in front of the floral display, her beautiful pink gown flowing from her like whispy cloud. As Bob and Jeanette chatted she started coughing, then sneezing. I handed her a paper kerchief. There were tears in her eyes as I switched on my lights. Suddenly the sneezing deepened into a choke and then, gasping for breath, she rose and stumbled toward the camera.

"Clarence, I can't breathe!"

Gasping, I caught her in my arms. Bob quickly called the studio hospital, as I laid Jeanette on the chaise I used for happier moments. She breathed heavily and desperately as I fanned her face with a newspaper. She tried to smile through the ordeal, as brave as anyone could be.

As the ambulance attendants lifted her gently on a stretcher and carried her from my studio Bob and I stood frozen, wondering what had happened to the most famous singer in pictures.

We didn't learn of her problem for several days. In the hospital she smilingly said.

"Clarence, you should add 'M.D.' to your credits."

I looked puzzled.

"Your bower of flowers—I am allergic to them. Quite by accident, I've found out something that might have been very serious."

In this strange way MGM saved much time and money and the health of Jeanette MacDonald.

Following a concert tour in 1948 Jeanette made a comeback in *The Sun Comes Up,* a co-star with the great dog actor, Lassie. Remembering the allergy, samples of Lassie's hair were taken and Jeanette was tested. Happy for all she wasn't allergic to the world's most beloved four-legged actor.

Jeanette MacDonald and Nelson Eddy

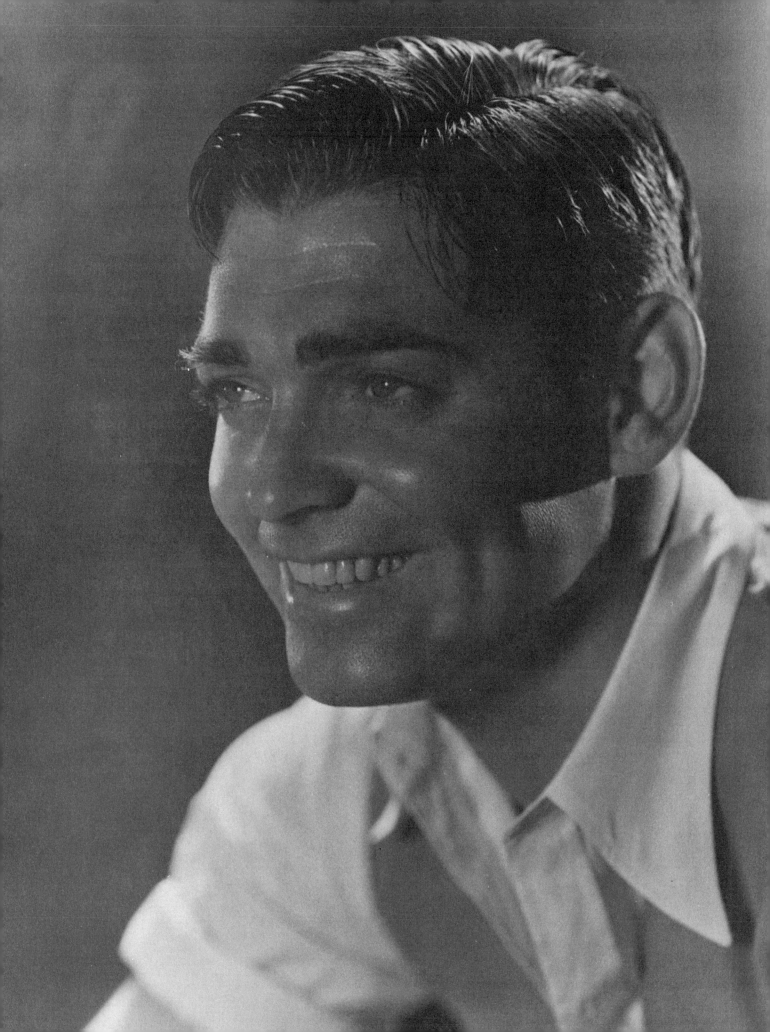

15

Only One Was Called "The King"

On November 17, 1960, a King died. He was the most revered monarch of his times and came closest to ruling the world. Only one man could answer that call—Clark Gable.

While reading the many praises of Gable I was most struck by what Vernon Scott wrote:

"He played a man's man in a man's world as opposed to the Marlon Brando types who portray mixed-up, emotionally unstable weaklings."

As an actor Gable was at home in a bar, a drawing room, a dive, a cell-block or on the war-fronts of history. He always looked the same: a man—a man against heavy odds. He always won, even against the odds of a bad scenario. His drive held both men and women through any kind of plot. They believed him because he believed in himself.

I'll never forget our first meeting. He stalked in like a restless lion and began pacing. He talked about his theatrical experience and now his chance in movies and then he pulled at his ears like an eagle does his wings.

"What am I going to do with these flaps? I have to watch about closing doors too fast, Clarence."

I laughed.

"You'll create a new trend. Women were excited by Valentino's nostrils, why not about your ears? Think what a woman can do with an ear."

He dimpled those cheeks and coyly answered: "Mister Bull, you ain't no gentleman."

And that was how our years of friendship began.

I could tell dozens of stories about Clark, but the one most characteristic of the scope of the man took place while we were doing publicity shots for *Gone With the Wind.*

On the old Southern staircase set at MGM we were waiting for a young lady. Many had been waited for on this old relic of the slave days. But today was truly momentous.

We had been waiting for over an hour for Vivien Leigh, who was to play Scarlett O'Hara to Clark's Rhett Butler. The shots were in costume. Clark was pacing back and forth. As I watched the lines deepen around his mouth and his stride grow longer I wondered if the great Civil War epic might have to find another star to play its immortal hero.

"Clarence, who do these English actors think they are? Have I ever been late for a sitting with you? Have I ever held up a company even five minutes?"

I shook my head, knowing how prompt Clark had always been.

"I hate prima donnas and this Leigh dame is sure starting out like one. If this is her way of doing a film I just might not make 'Wind' with her."

As he saw the grin on my face he got the double meaning but tried to hide any implication of humor.

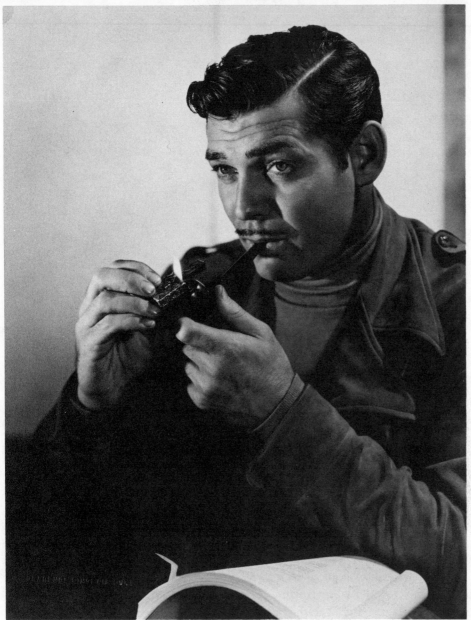

Clark Gable

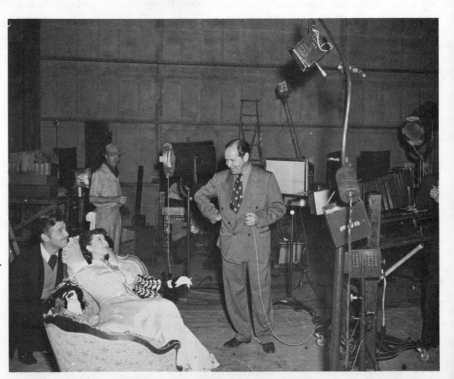

Gable, Vivien Leigh, and Clarence Bull setting up shots for "Gone with the Wind"

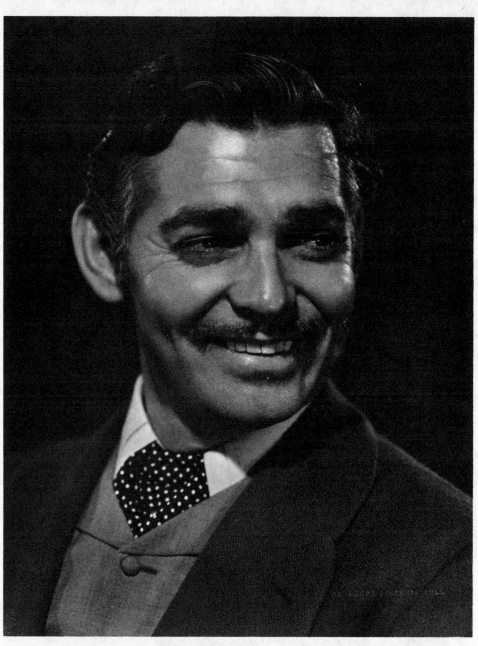

Clark Gable (from "Gone with the Wind," 1940)

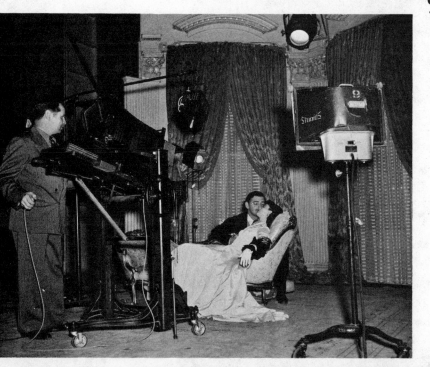

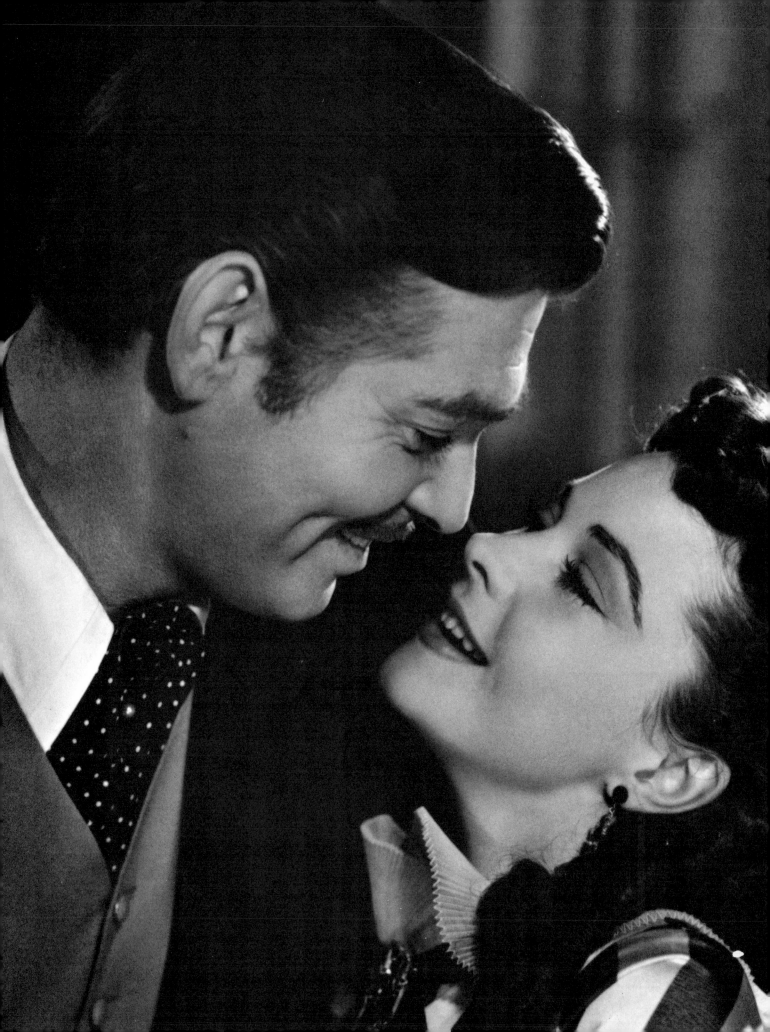

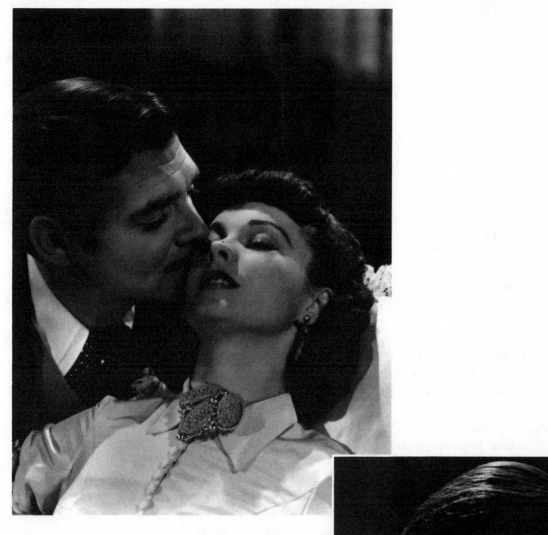

Gable and Vivien Leigh

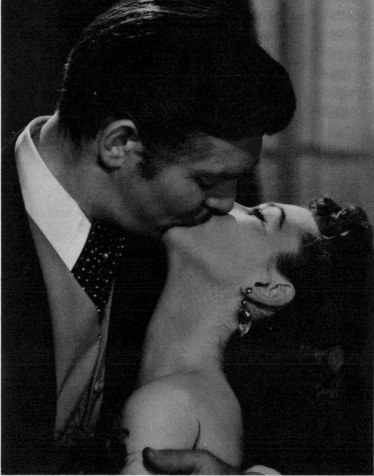

Several of the crew standing by exchanged looks. A Gable temperamental storm was rare. He was always the most cooperative guy on the set. He always knew his lines. He made a very complicated task of being a star look quite casual.

I realized it was high time to do something. After all, I didn't know Vivien Leigh. I told him I was going to call the man who'd made the appointment and find out what had happened.

When I reached him on the phone he said his secretary had told Miss Leigh the sitting was for three instead of one o'clock. I rushed back to Clark who was chewing a cigar to shreds and related the misunderstanding.

"O.K., Clarence. I'll pipe some air for a minute or so. But I'm doing this for you, old buddy, not that gal!"

As I watched him barge through the stage door I smiled. No more natural male ever lived. That was his genius. No tricks. No fake. No histrionics. Nature itself on the Adam-side molded into one hunk of male animal.

I thoroughly looked forward to working with Gable. He'd come banging into my gallery generally with a story on the tip of his tongue and while he told it I'd set up shop. As he moved and shifted I'd look at him and he'd stay put and I'd click my shutter. He had to be on the go before he reached the desired pose.

If he had Jean Harlow with him they'd kid around and wrestle until I'd say let's heat up the negative. And, they almost burned it clean through. I've never seen two actors make love so convincingly without being in love. How they enjoyed those embraces! And the jokes and laughter.

The King and the Queen of their times. Hell, they were everybody's lovers in any narrow corner of the world. Too bad in their seething make-believe they couldn't have found the love that so many times eluded them.

Suddenly Gable was back on the stage growling like the MGM lion.

"Its been twenty minutes since you called and where is she?"

I thought I heard the sound of grinding teeth.

He was staring down at me as he would in *Gone With the Wind* and saying:

"I couldn't make love to that dame now if she were the most beautiful woman in the world!"

And then, a rustle of silk, the sweet smell of lilacs and there *was* the most beautiful woman in the world, standing behind him, touching his shoulder, whispering like a summer breeze:

"I quite agree, Mr. Gable. If I were a man I'd tell that Vivien Leigh to go right back to merry old England and . . ."

Gable turned and looked. Leigh looked back. The look in their eyes had flash bulbs in it. Slowly Rhett Butler took Scarlett O'Hara by the arm and walked onto the Southern staircase, talking and smiling as though they'd known each other all their lives.

After a little short conversation the stars took their places and began emoting for my camera. I clicked like mad. I've never seen such excitement between two strangers. Suddenly I realized in my own excitement I had forgotten to load the camera. But I said nothing to the Southern lovers. I suggested a change in the lighting and then loaded up. They didn't 'pay me no mind' as some southerners say.

Miss Leigh was glorious and Mr. Gable magnificent. And when I recall the bad start these two had, it's a wonder how they merged so beautifully. But this is part of the actor's equipment. And when he meets another actor of his own caliber it fuses into a flame that burns forever in the hearts of movie fans the world over.

In my first sittings with Gable problems arose. The photos were not just Gable. I'd missed capturing the man behind the mask. We discussed this and tried many ways of getting him to relax, none of which were alcoholic.

Publicity called for an "outdoor" spread. On one of the stages I found a stream, trees and a shoulder of rock that suited the setting to a T. But again Gable froze.

"I don't know what in hell's wrong with me, Clarence."

The electrician who was helping with the lights remarked.

"Maybe you need some live game for realism. I hear the doves are plentiful in San Fernando this year."

"Well, Clarence, what's keeping us?"

"I'll call publicity and suggest some informal hunting scenes."

I called and they ok'd the outing.

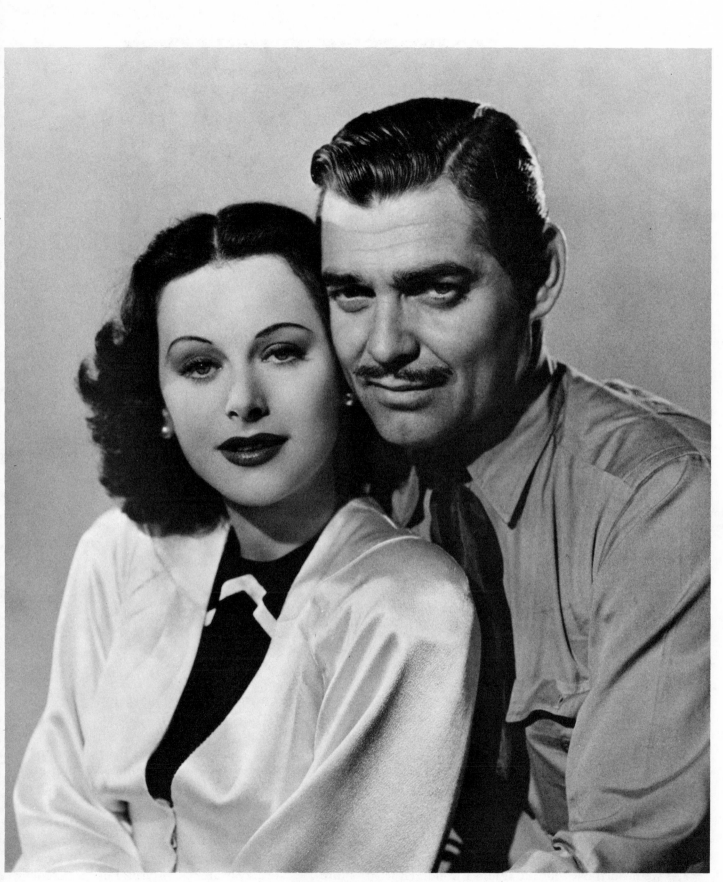

Gable and Hedy Lamarr

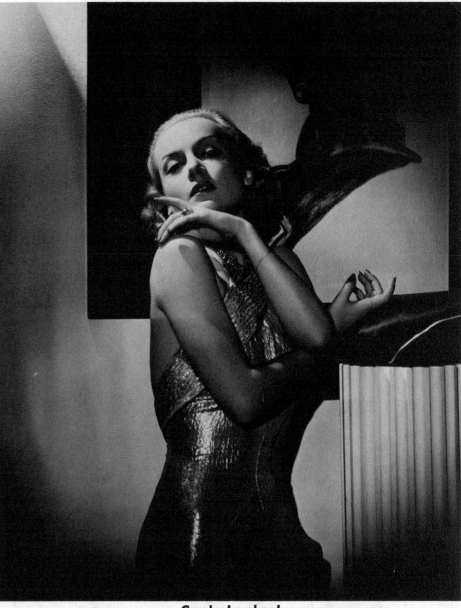

Carole Lombard

At a sporting store near the studio we rented a couple of rifles and got our licenses, and with Gable at the wheel of a Cadillac we raced out to the Valley.

Before I could look for my camera Gable was out of the car and loading up. When I finally was able to look for my camera I found I had left it at the studio. Gable was banging away as I tried to explain the dilemma.

Clark got the limit and I missed by three birds. As we headed back for the studio I wondered what I would tell publicity.

"Tell them nothing. You have props in your studio, don't you?"

I nodded.

"Well, what you don't have we'll scrounge up."

I was amazed at our assimilated "hunting grounds." And Clark looked like the gamest game hunter of all time.

No other screen hero loved so many beautiful and fascinating women.

Jean Harlow . . . Greta Garbo . . . Joan Crawford . . . Norma Shearer . . . Myrna Loy . . . Carole Lombard . . . Claudette Colbert . . . Lana Turner

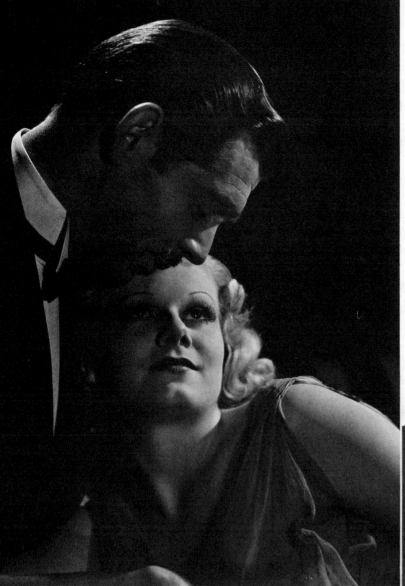

Gable and Harlow

. . . Hedy La Marr . . . to name a few.

I have been asked many times if Clark had a favorite. And as I said previously Jean Harlow had to be her. They were the most exciting screen lovers of their times and that included Garbo and Gilbert.

Of his personal loves: Carole Lombard was the woman a man's man dreams of; her tragic air-crash death while selling bonds in World War II was Gable's deepest sorrow. Yet Kay Gable gave him his greatest joy, a son; but John Clark Gable will only see his father on film, since death dethroned the King before his birth.

A little lunch wagon that parked outside MGM rounded the circle for Clark Gable and me. We had our first lunch there when he was marked for star-dom. Years later he came to my studio and asked me to lunch with him again. Munching a hamburger, he said:

"We first broke bread here, old buddy. Remember. And now the last time. Always a last time. It was great working with you Clarence. Only you could hold down by flaps."

He stood up and paid the check. We shook hands. The King walked down the street as I watched. There was not even a shadow to pay tribute to this greatest box-officer of his time.

I couldn't believe it as I stumbled inside the gigantic film factory Clark Gable had help build.

No screen role for Clark Gable?

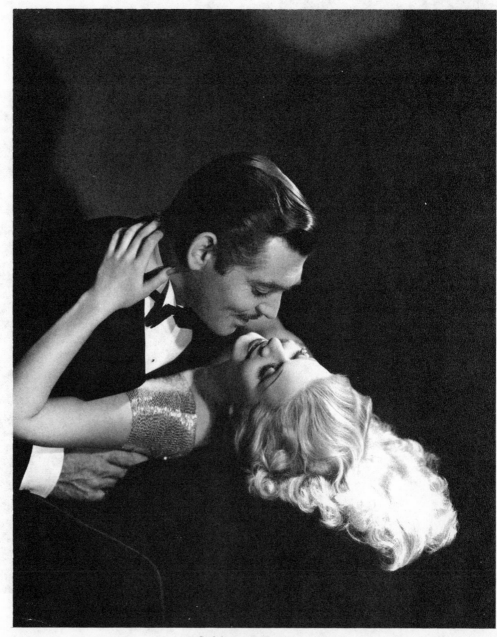

Gable and Harlow

16

Jean

As the reigning sex queen of the throbbing Thirties Jean Harlow's crown of platinum blond hair was a glory no other star ever matched. Extremely difficult to photograph I was the only lensman to catch its natural silken sheen and, oddly enough, due to the emergency use of a surgeon's operating light.

To keep its platinum quality required meticulous care in lighting. Other photographers had "over" lighted it. The prints showed her hair as a burned-up snow white blob.

Jean Harlow was the most considerate and thoughtful star I ever worked with. She would always be doing "little" things that in someone else would turn up as a "production." She loved people and despite recent comments she never hated anyone. Her biggest weakness—she loved too much.

Quite discouraged about the poor photos appearing in fan magazines she called me and stated the problem and wondered if I could help. She said I was recommended by "the best people." I laughed and told her I could certainly try.

In our first sitting she was quite nervous and yet she joked with, "Maybe I'm using the wrong rinse," and all her vibrant beauty lit up my studio like a moonshot.

In that first sitting I fell in love with Jean Harlow. She had the most beautiful and seductive body I ever photographed. But this wasn't what attracted me to her. I loved her enthusiasm, her love of life.

I knew she was destined to be a star of the first magnitude and yet I also saw a faint shadow trailing all the glamor and world acclaim and I wanted to protect her which sounds corny as hell. But that was my love for the little girl with a voice like a brass ring and a heart that beat like a church bell.

My first prints weren't as bad as the others but I still felt like the hero of Kipling's famous novel, *The Light That Failed*.

Late one afternoon Jean called me and asked me if I could manage a few stills on the *Red Dust* set after the day's shooting was over. Gable had promised to stay for a couple of shots.

We shot Clark's clenches first and he took off.

The big stage grew slowly quiet and seemed to descend on us as I set up my camera for a single on Jean. As I was putting my lights on I glanced at the far end of the stage and saw a hospital operating room. When I spied something else my heart pumped like a bellows.

Jean ran over and asked me what was up. I put my finger to my lips and motioned to a prop hand friend of mine who was dismantling the set. Jean was like a kid at a circus waiting for the next act. When my friend came over I pointed to the surgeon's light and asked him if I could borrow it for awhile. He grinned and with Jean smiling all over the stage what else could he do?

It worked like a charm; it easily adjusted to any angle or any amount of light. I knew the prints

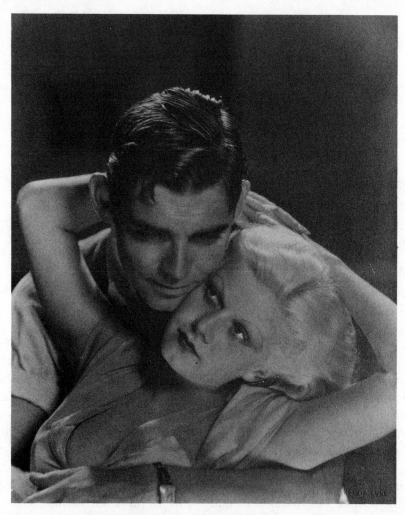

Gable and Harlow (from "Red Dust," 1932)

would be perfect—the hair was a crown of glory.

I told Jean I just had to have that light. Jean winked at the prop man who turned his back as she flung her fur coat over the lamp and between us we "liberated" it from the stage.

Jean watched me develop the prints and when I smiled she kissed me smack on the lips. Later when I made the prints she had tears in her eyes. That was the way it was with this luminous girl.

I never used the light on anyone but Jean Harlow. I called it "Harlow's Halo." And when other stars came to pose or directors and producers to browse among my files of portraits, I always hid it wondering if someday the head of the property department might be still on the hunt for his missing surgeon's light.

I have been told it's the granddaddy of present-day boom lights. Boom lights are usually spot lights on an arm that can be handily moved about for overhead lighting in a close-up.

When sound flourished the use of the boom light was adapted to hold microphones. Mike booms are now quite elaborate but they owe their origin to a prop surgeon's operating light that haloed the crowning glory of an immortal gal of glamor and heart—Jean Harlow.

Aside from her unique beauty, Jean was the most completely feminine woman I ever had the pleasure of photographing. Hed body would excite a statue and yet the way she walked, the movements of her thighs and legs, had nothing but beauty in them. She was all woman and looking for all man. And this is the strange magic of her appeal to both men and women.

As to nudity and stripping and scratching her breasts at the slightest provocation I, as her—I

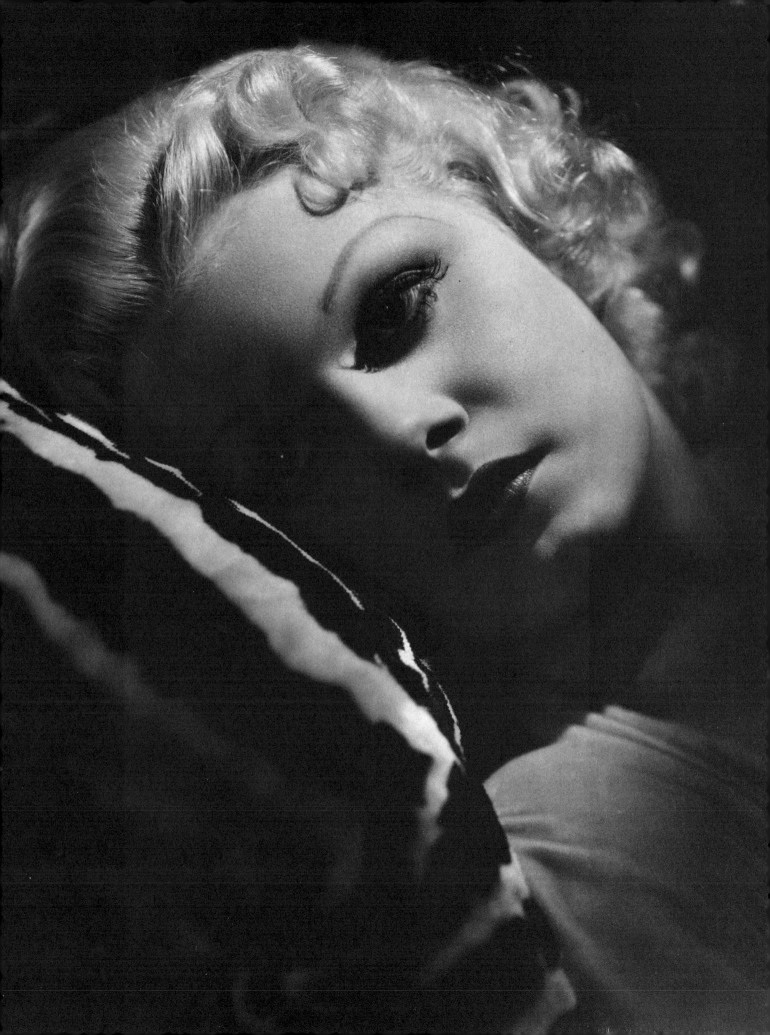

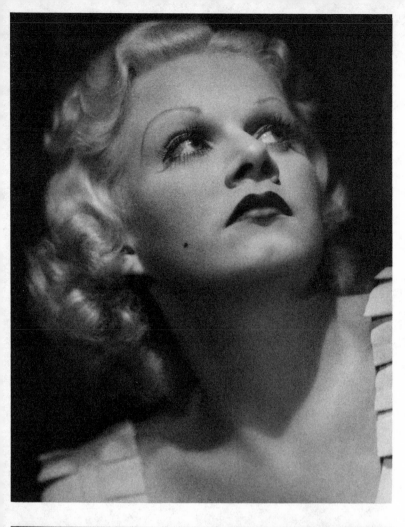
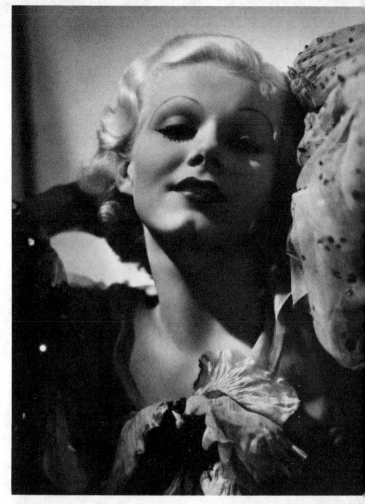
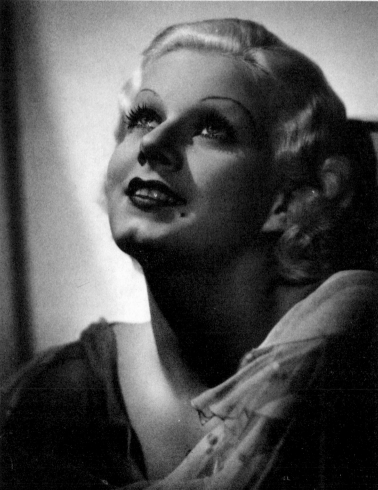
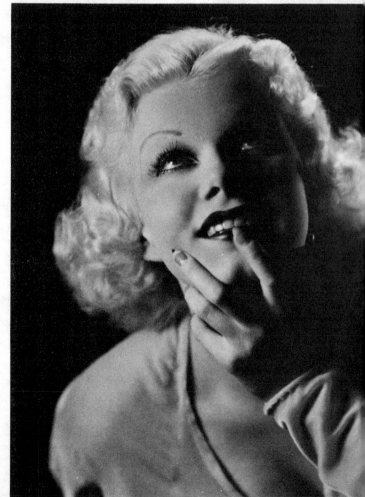

would like to think favorite—portraitist, never saw this display.

Some time later I was given the assignment of making candid shots of Jean around her new home she was building on Beverly Glen Drive. Here we go, I thought, the old corn—a beautiful chick helping build her new home and she doesn't know a hammer from a saw, or a nail from a screw. I just could imagine the blond bombshell prowling around lumber and cement and bulldozers.

When I showed up with my camera and Jean, going to a circus again, the builder took a dim view of our presence. But when Jean started talking about the blueprints as though she'd made them, he melted.

As she strolled away to take a look at the surrounding scenery, he pulled me to one side and said, "I know she's the most beautiful dame in films but I never thought she had brains enough to understand a blueprint."

Later when the house was completed and landscaped, and Jean and her folks moved in and settled, we had another session. It was mostly a fashion lay-out inside and out of the beautiful hilltop home that later sold for $125,000.

A memorable shot was of Mama Jean and "The Baby," as her mother called her. Mama was in black and Jean in white. But the smiling relationship between them was quite captivating.

When the pictures were all shot we had drinks. I never saw Jean drink with anyone though some say she did. It was a hot day and the pool, beside the two-story white mansion was our next adventure.

As we frolicked and splashed suddenly Jean shouted from the far end. "Clarence. Clarence!" Knowing she was not a good swimmer I swam quickly over to her and grabbed her in my arms. I let go quick as silver. She was stark naked!

"I've lost my lower half, Clarence, please find them."

I dove like mad every which way and sure enough I came up with her crimson lowers. And my stomach had more water than inerds and Jean was hanging onto the pool steps laughing as happily as I would ever see her.

Suddenly her secretary came running from the house whispering in Jean's ear.

"Oh, Clarence," she squealed, "a reporter from a fan magazine. I'd forgotten about. Hurry!"

I flung the trunks on the deck as the secretary rushed off to hold back the press.

As I turned my back Jean donned the trunks and leapt out of the pool. So radiant and alive! She was spun with gold from top to bottom! Wait. Bottom. As she composed herself and moved to meet the press, I tried not to sound loud as I said:

"Jean, you've got your trunks on inside out."

Her lovely hair was whirling like a silver dervish as she looked back at me and floored me with:

"Clarence, I'm not a boy so who's to know inside or out!"

Saratoga, with Gable, was Jean's last film. I never saw her so full of zest and vim. She rollicked through the work-days.

The publicity department was anxious for advance photos so instead of waiting for the last day of production I told Jean we'd have a sitting a few days before.

I'll never forget her voice on the phone that day. It wasn't Jean. And yet it was. I felt strangely upset about the *Saratoga* poster art.

I've never seen her so beautiful, so full of life. I took some on the set. When she suggested the others in her dressing room, I got a little twinge.

The last portrait taken. She looked at me. I looked at her. We both had tears in our eyes without knowing why. Slowly she came up to me and put her arms around my neck and whispered:

"Clarence, I'll never be here again."

"Nonsense, Jean, we have fashions to do in a few days."

"I don't mean that. I mean its goodbye to—to everything . . ."

I helped her on with her fur coat. I walked her to her car, which she was driving. I stared into her face and saw shadows I had never seen before. I kissed her gently on the cheek as she tried to smile away her tears.

"Goodbye, Clarence. Thanks for everything."

She kissed me softly on the mouth and drove off.

Not long after Jean Harlow was dead at 26. A dozen life-times had been crowded into this dynamo of a girl. The morning she was buried I went to my studio and looked at the hundreds of photos I had taken of her. I knew she would want me to remember her as I had seen her in my lens.

I looked at the surgeon's lamp, Harlow's Halo.

I felt sick at my stomach. I picked up the phone and called the property department.

"Gus, this is Clarence Bull. I've found something that's been lost for some time which belongs to you. . ."

17

A Teenage Vamp

Sex queen, glamor girl, sophisticate—these have been some of the titles tagged on the many beautiful women I have photographed through the years. But little did I realize that a set of pictures I shot for a gag to please a frustrated sixteen-year-old girl would one day be the first look at the reigning love symbol of the fifties and early sixties—Elizabeth Taylor.

In 1944, with her hit performance in *National Velvet,* co-starring Mickey Rooney, Elizabeth was my prime teenage subject. Sweet, simple, girlish, an angel in pigtails, she soon became a problem for one Clarence Bull.

After every session Elizabeth would begin to pout, complain and drop a few tears. Even a fresh batch of cookies a wardrobe lady baked for her, and which she always loved, failed to calm the girl down. I asked her what was wrong.

"I'm just a sweet young thing that nobody wants. I've never had a date and if I did mother wouldn't let me go out. Oh, if just once I could show everybody I wasn't a sweet young thing!"

Pacing up and down my studio she certainly didn't look like a sweet young thing.

"Elizabeth, you have your whole life ahead of you. Just be patient."

I sounded mighty pompous. She knew it and grabbed my shoulders and drew me close as if she were going to kiss me.

"Mr. Bull, please, please photograph me once in something alluring, and maybe a little—a little sexy! Just once, please!"

I had become so attached to Elizabeth I felt I had to do something. But what? I talked it over with a girl in publicity and we agreed to take some pictures of her as a sort of Lana Turner, Joan Crawford and maybe Theda Bara imitation.

After school one day when she arrived for a sitting I startled her pink by having on hand all the glamor girl stuff—a leopardskin rug, a low-cut black satin evening gown, a necklace of pearls, and a woman from wardrobe to help her get "allured up."

All aglow she draped herself on the leopardskin rug and struck a pose that would have startled even Louise Glaum, the original lady-leoparder. I had a laugh behind my camera and Jean muffed hers with a handkerchief.

Elizabeth slunk from one traditional vamp pose to another trying to look her best as the worst of the enchantresses.

When I showed her the finished prints she jumped up and down and kissed me wildly several times and grabbing them up rushed out of my studio. I laughed and remembered Bernard Shaw's line about youth. It was a harmless gag for a confused child. What was wrong in that?

A few days later rumors rumbled back to me. Elizabeth was taking the photos to every producer on the lot stating now she had proof she could play

Elizabeth Taylor, as she appeared in "National Velvet"

grown-up parts. They must give her a glamour role.

I still thought it just a child's prank. When I got a call from Ida Koverman, L.B.'s secretary, I wondered otherwise. The head of the MGM lion kingdom called people into his inner sanctum for two things—to hire or fire them.

"Mr. Mayer, you sent for me."

I didn't sit down.

"Yes, Clarence. I'm wondering if we hired you for the wrong department."

I looked puzzled.

"Maybe you'd do better in casting."

I got the point.

Suddenly he dropped his maned manner and walked over to me.

"I haven't had such a good laugh in a long time, Clarence. Those photos of that beautiful child mimicing Bara, Turner and the rest were a riot."

He put his hand on my shoulder as if he were going to knight me.

"Growing up is hell for some. For this lovely child, maybe double trouble. Who knows? But thanks to your stills I'm giving Miss Elizabeth Taylor her first grown up part opposite Robert Stack in *A Date With Judy.*

My camera sits quiet now. Only on special assignment does it catch any of today's beautiful faces. As for me I lecture on present-day camera trends and improvements and enjoy comparing the past with the present for photographers all over America.

But how can you compare Harlow and Garbo, Swanson and Shearer, or Gable and Tracy with any luminary today? Maybe it's just an old timer's sentiment. But today's faces lack depth of feeling. Two world wars and many minor ones have almost changed the face of the globe itself. Why not our actors?

As I watch on television many of the stars I once photographed, I look at them as one might old paintings. Some can't stand up to today's demanding audience; others will be as magnetic a hundred years from now.

I am sure the Mona Lisa and the face of Greta Garbo will inspire and puzzle for all time.

The Faces of Hollywood

Eadie Adams

Elizabeth Allan

June Allyson

85

Pier Angeli and Clarence Bull

Pier Angeli

Robert Armstrong

Garbo and Nils Asther (in "Wild Orchids")

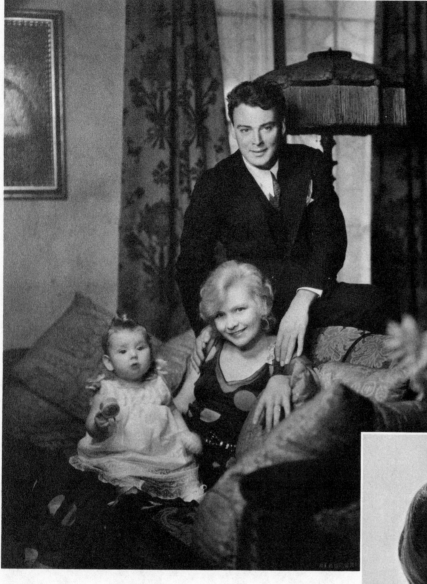

Nils Asther with his family (1931)

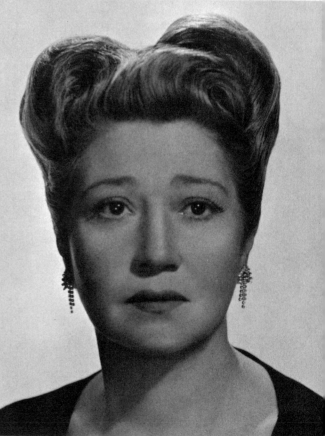

Fay Bainter

Lucille Ba

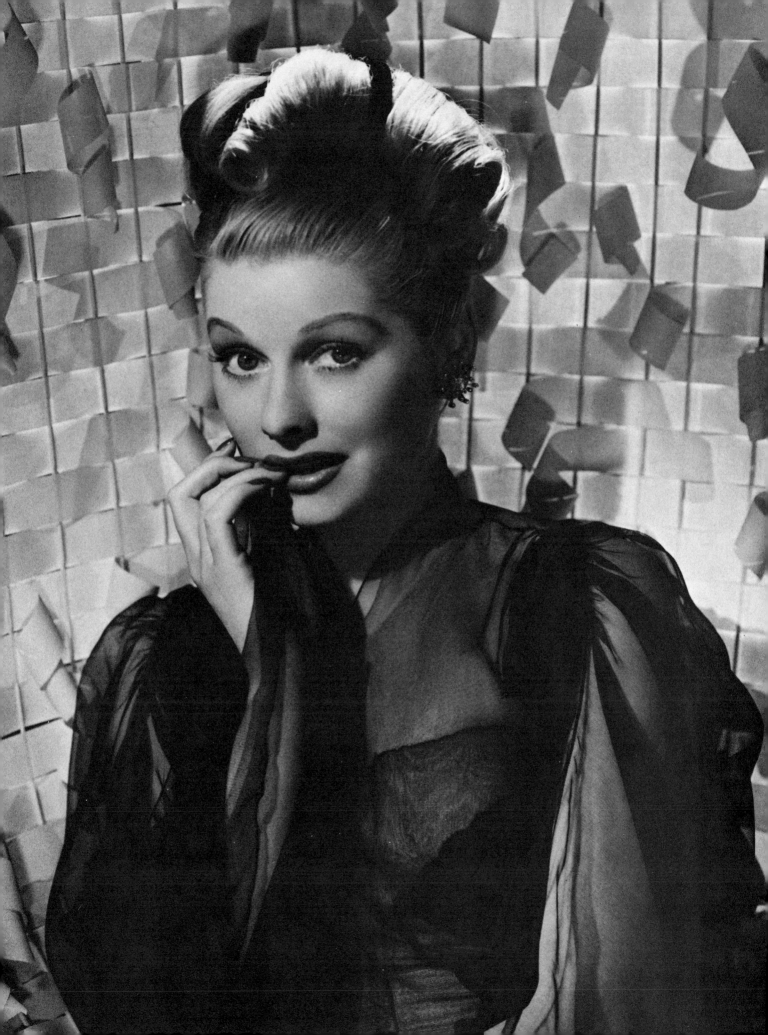

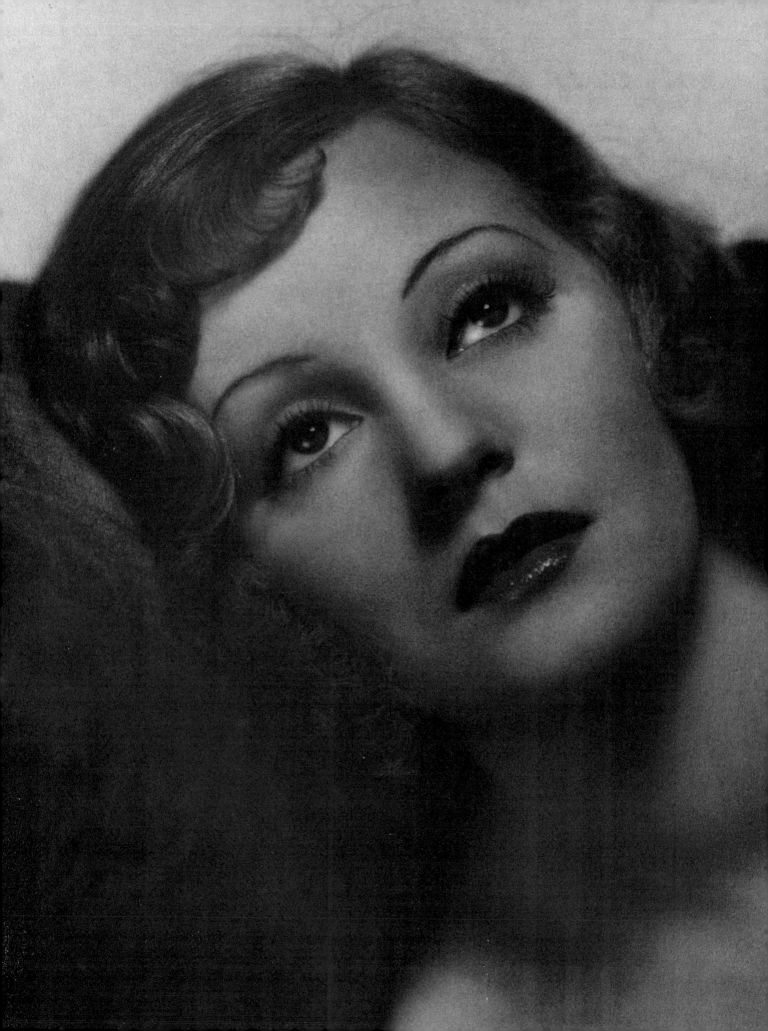

Eleanor Parker

John Barrymore

Tallulah Bankhead

Freddie Bartholomew

Lina Basquette

Barbara Bedford

Harry Beaumont and Jack Pickford

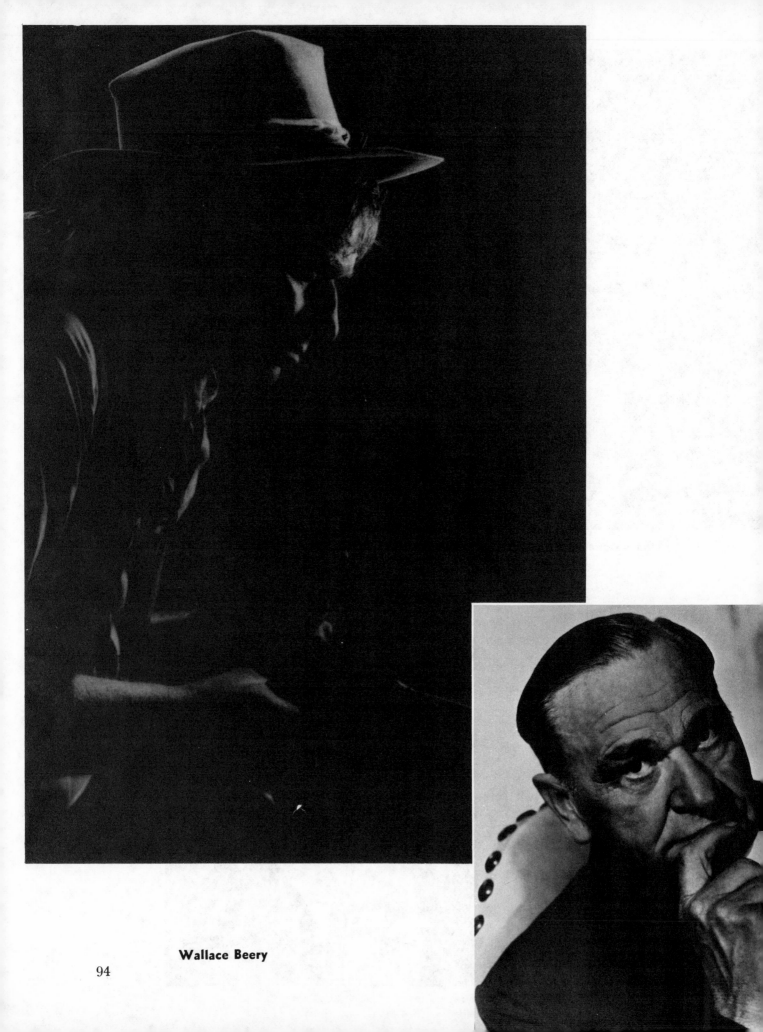

Wallace Beery

Joan Bennett

Wilda Bennett

**Pamela Blake (from "Slightly Dangerous,"
1943)**

96

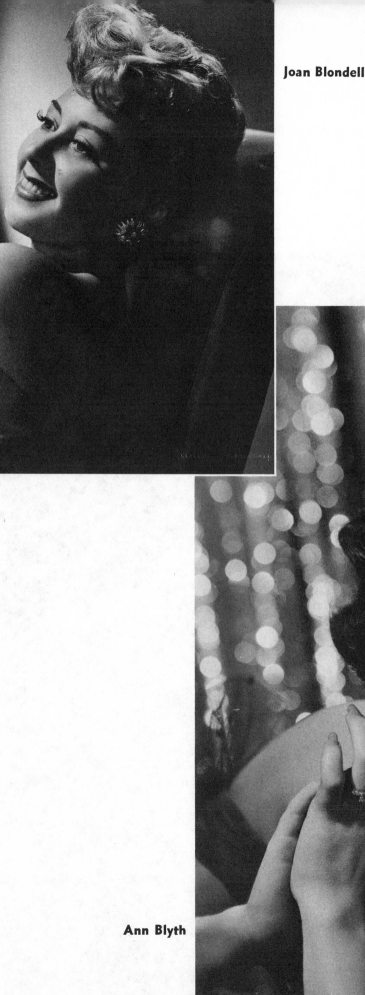
Joan Blondell

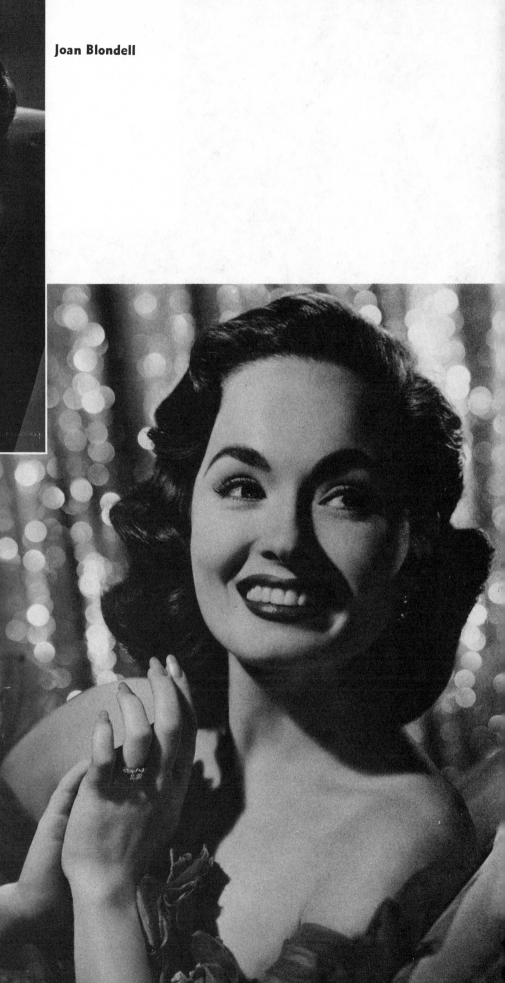
Ann Blyth

Betty Blythe

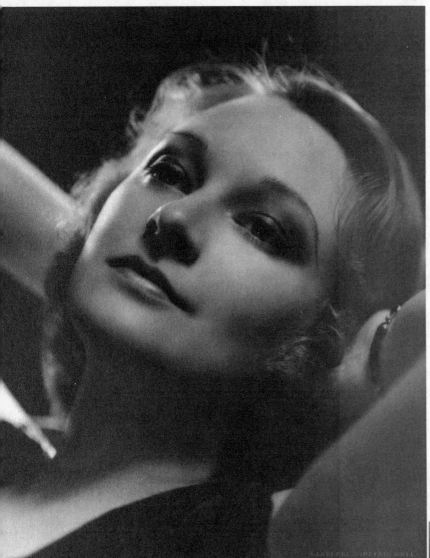

Eleanor Boardman (1931)

Priscilla Bonner

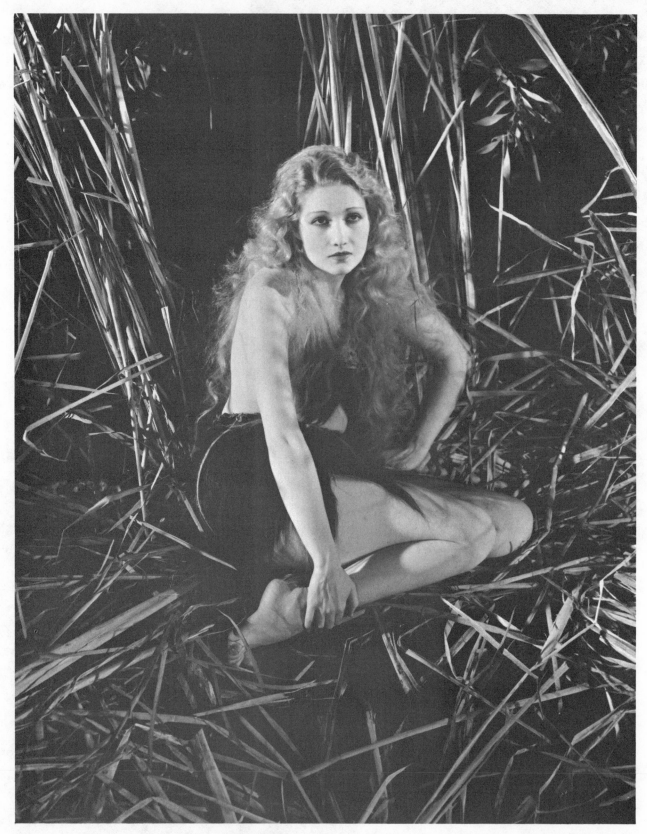

Edwina Booth in "Trader Horn"

Hobart Bosworth

John Bowers

Alice Brady

102

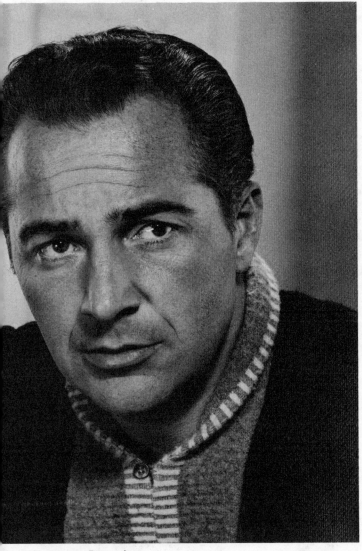

Rossano Brazzi

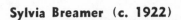

Sylvia Breamer (c. 1922)

Lorraine Bridges
Johnny Mack Brown
Virginia Bruce

Laurette Taylor

Billie Burke (1933)

Ralph Bushman

106

Charles Butterworth

Bruce Cabot

Louis Calhern

Joseph Calleia

Ora Carew

109

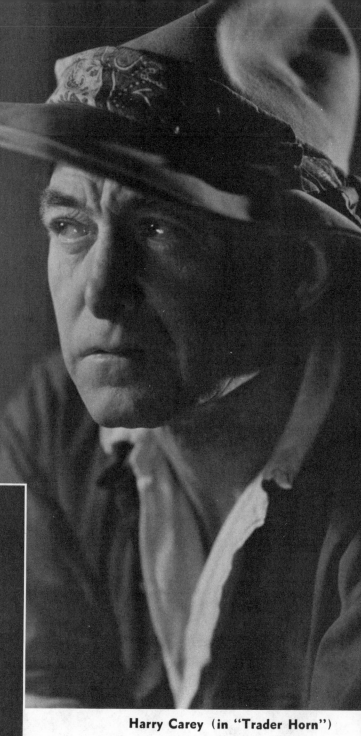

Harry Carey (in "Trader Horn")

Leo Carillo

Mary Carlisle

Leslie Caron

John Carroll

Nancy Carroll

Barbara Castleton

Helene Chadwick

Cyd Charisse

(from a cover of "Colliers")

114

Virginia Cherrill

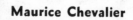
Maurice Chevalier

Naomi Childers

116

Claudette Colbert and Clark Gable

Ethel Barrymore Colt (1932)

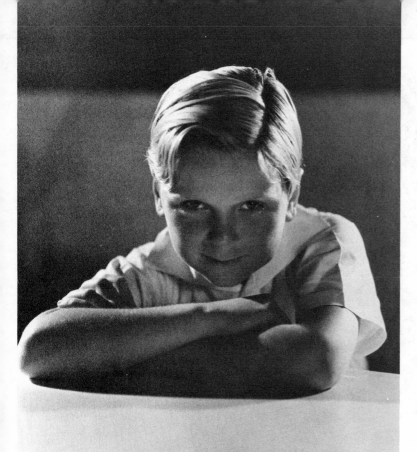

Jackie Cooper (1931)

Jackie Cooper (1932)

Ricardo Cortez (1933)

James Craig (1947)

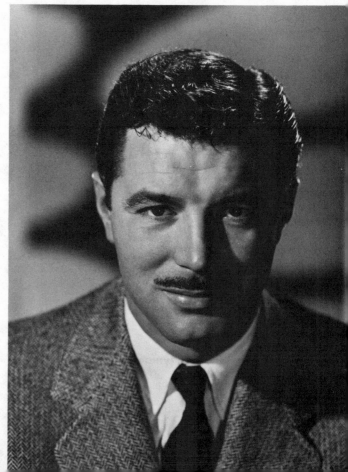

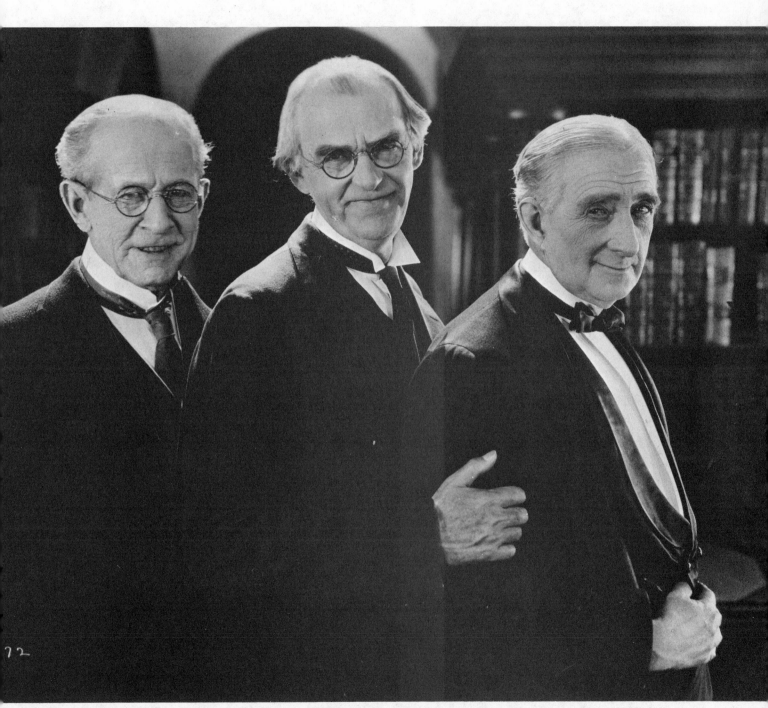

Ward Crane, Claude Gillingwater, and Alec B. Francis

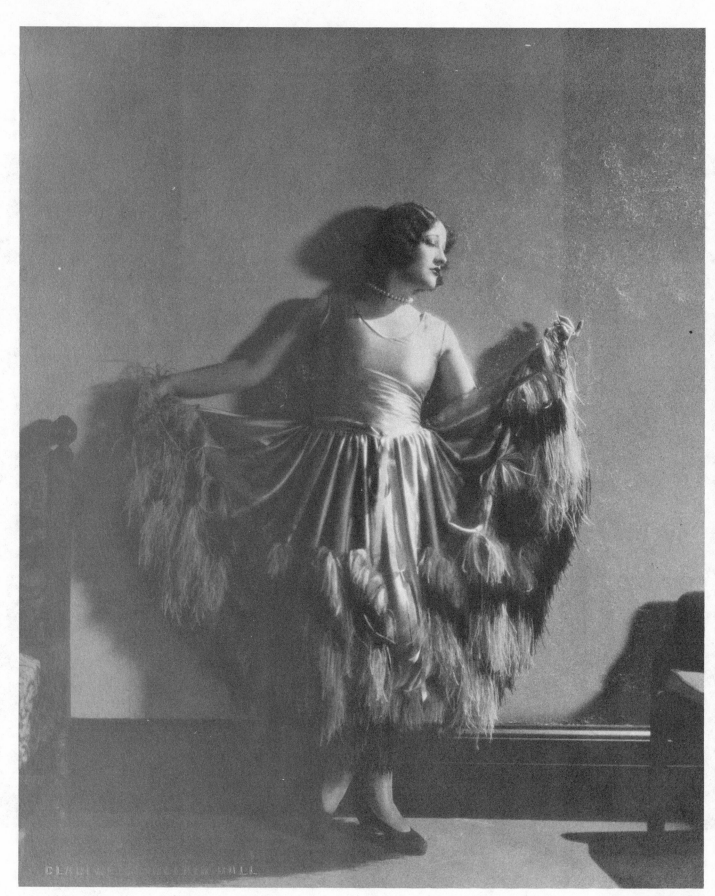

Joan Crawford

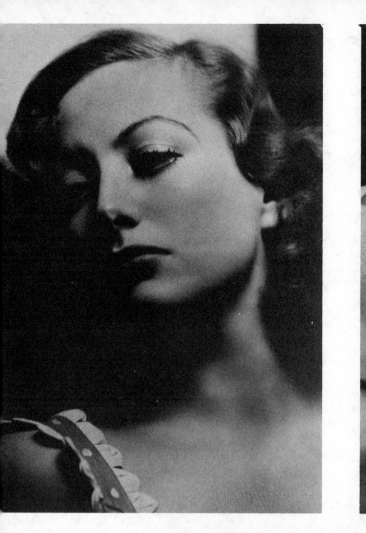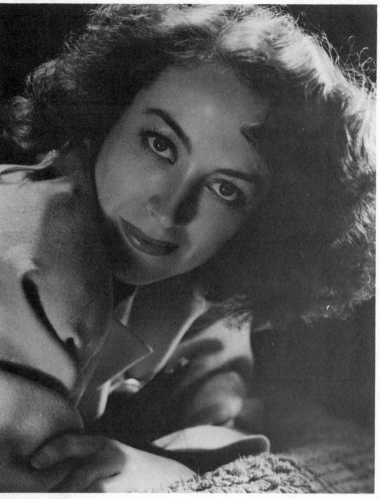

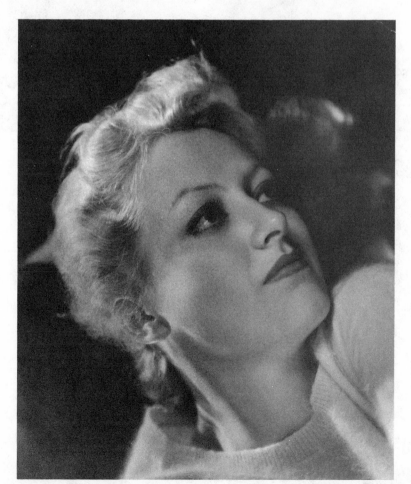

Arlene Dahl

Lili Damita

Viola Dana

Marion Davies (1932)

Nancy Davis (Mrs. Ronald Reagan)

Laraine Day

Gloria De Haven

Dorothy Devore

Dolores Del Rio and her husband, Cedric Gibbons

Reginald Denny (1931)

126

Marlene Dietr

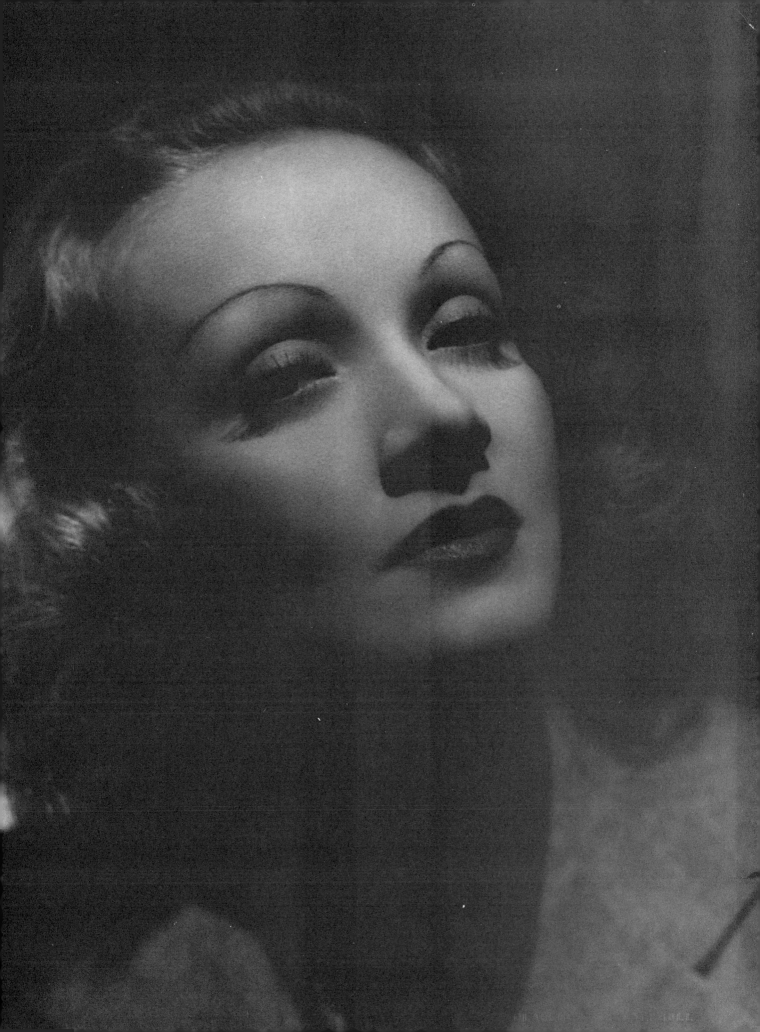

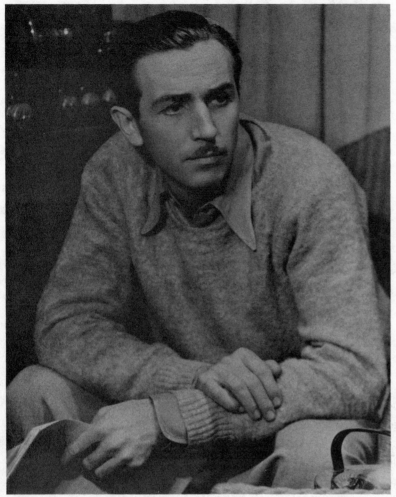

Walt Disney

Richard Dix

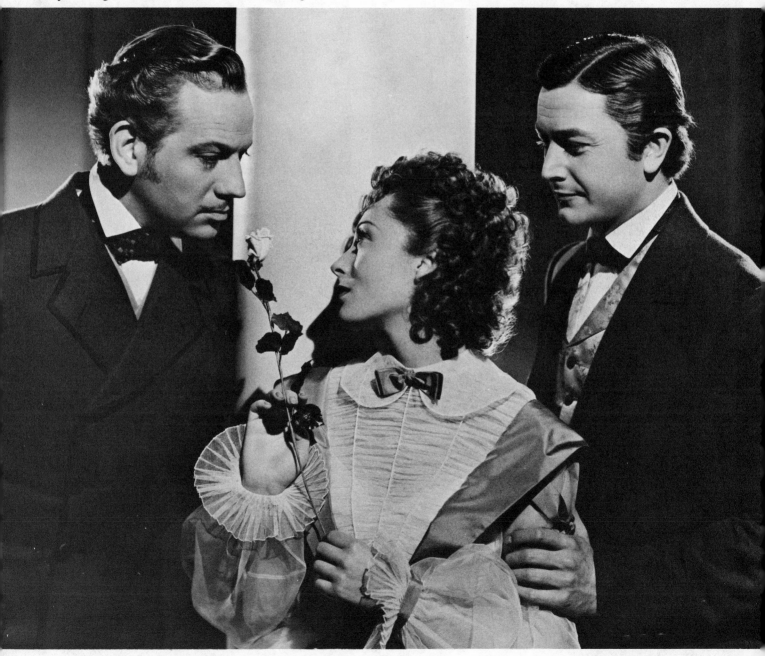

Melvyn Douglas, Luise Rainer, Robert Young

Marie Dressler

Mary Duncan

Irene Dunne

Jimmy Durante

Jeanne Eagels

Buddy Ebsen

Taina Elg

Vera-Ellen

Stuart Erwin

Madge Evans

Louise Fazenda

Ralph Forbes (1928)

Alec B. Francis

Wallace Ford (1931)

Anne Francis

Helen Ferguson (1924)

Betty Furness

135

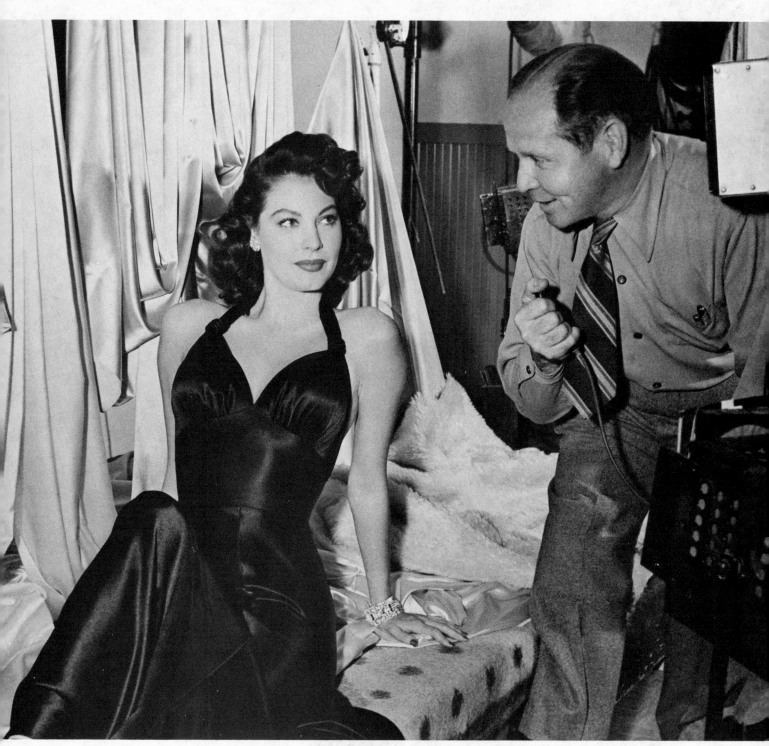

Ava Gardner and Clarence Bull

Ava Gardner

Judy Garland

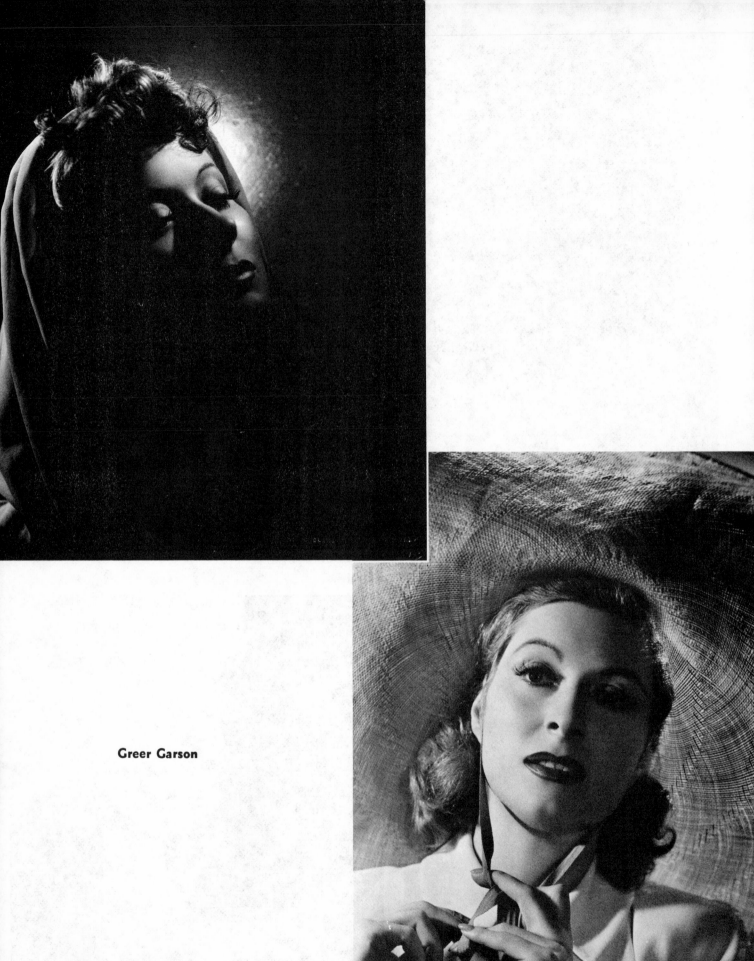

Greer Garson

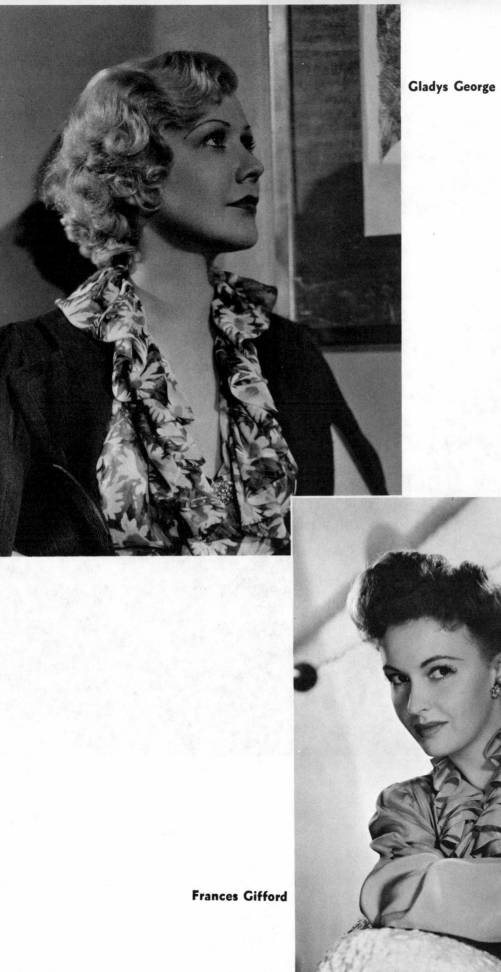

Gladys George

Frances Gifford

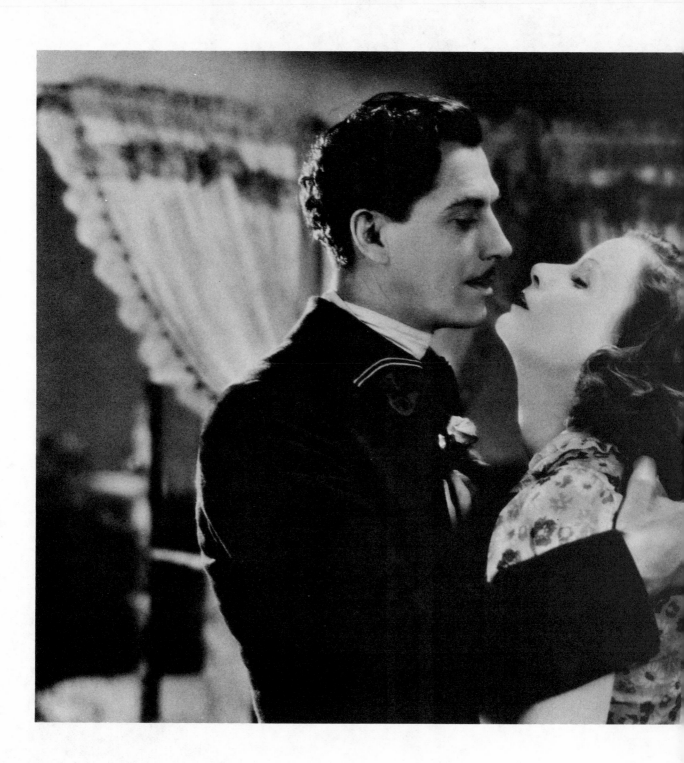

Garbo and Lars Hanson (in "The Divine Woman")

John Gilbert

Lillian Gish

Igor Gorin

142

Gloria Grahame

Kathryn Grayson

Charlotte Greenwood

Joan Greenwood

Corinne Griffith

Virginia Grey

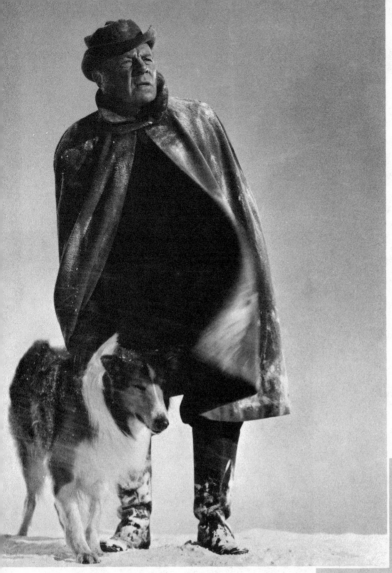

Edmund Gwenn and Lassie

Edmund Gwenn

Jean Hagen (1950)

Ann Harding

Creighton Hale

William Haines (1932)

Helen Hayes as "The White Sister"

Signe Hasso

Phyllis Haver

Helen Hayes (1933)

Madame Schumann-Heink

Ted Healy

Audrey Hepburn

152

Jean Hersholt

Irene Hervey

Phillips Holmes

Miriam Hopkins

Lena Horne

Walter Huston

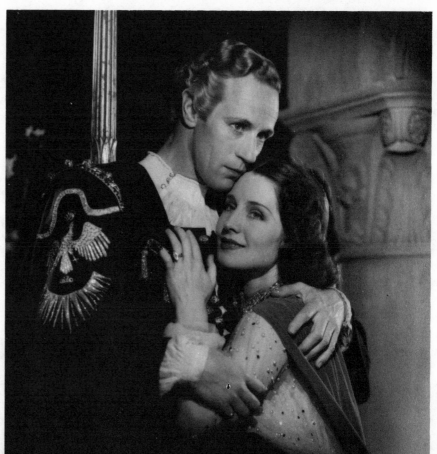

eslie Howard and Norma Shearer in "Romeo
nd Juliet"

Benita Hume

Ruth Hussey

Leila Hyams

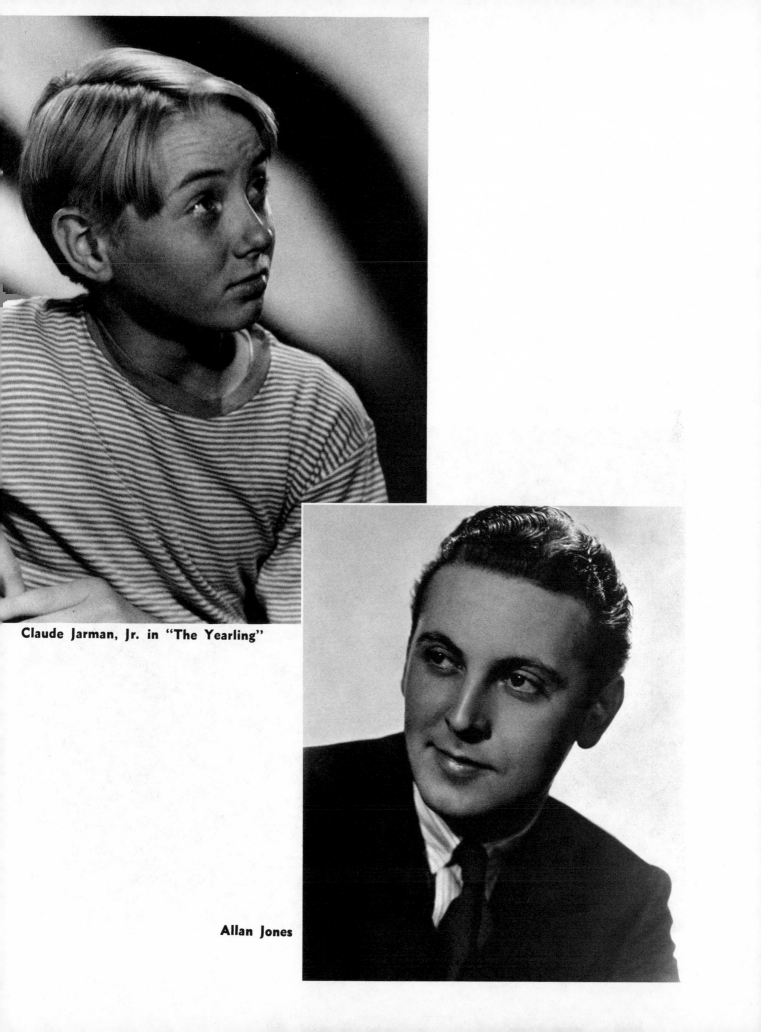

Claude Jarman, Jr. in "The Yearling"

Allan Jones

Dorothy Jordan

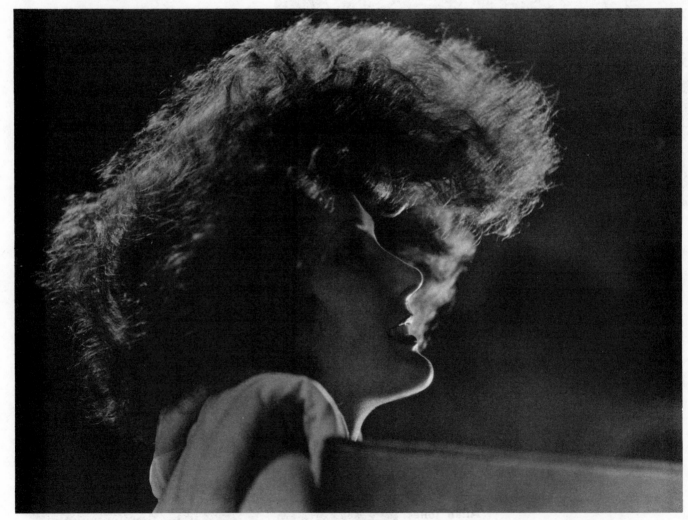

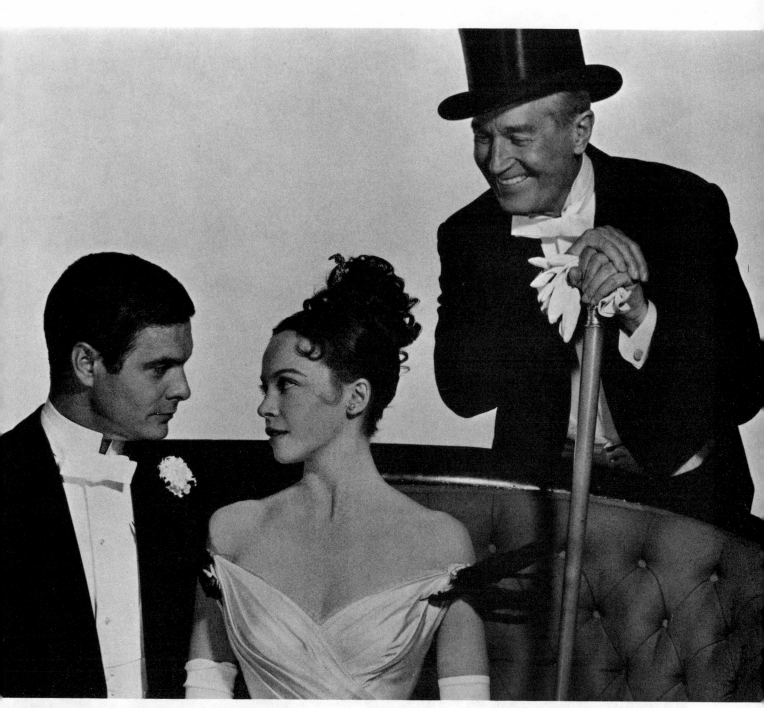

Louis Jourdan, Leslie Caron, and Maurice
Chevalier (in "Gigi")

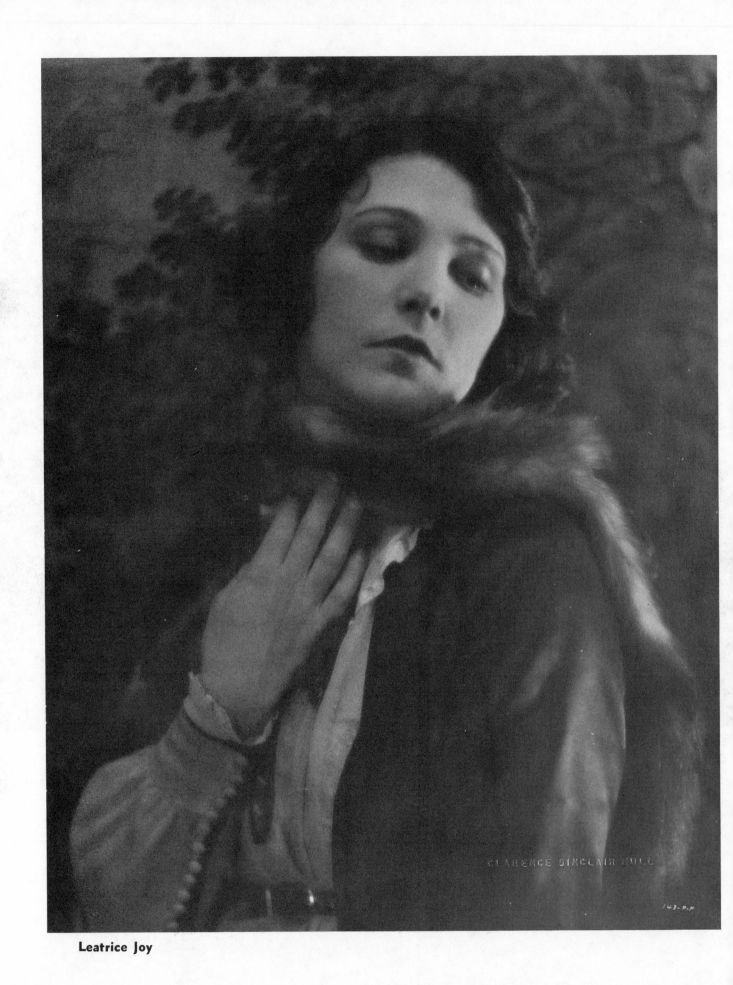

Leatrice Joy

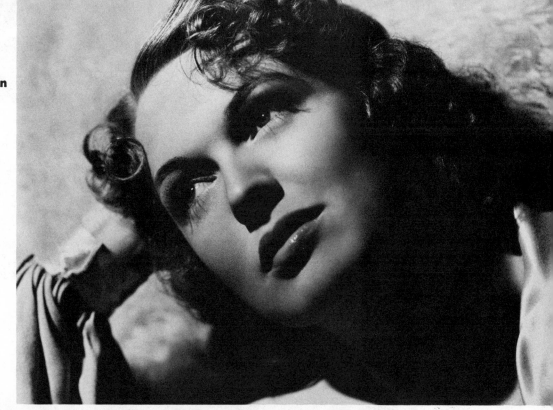

Rita Johnson

Buster Keaton

Howard Keel

Joe Keaton (Buster's father)

Gene Kelly

162

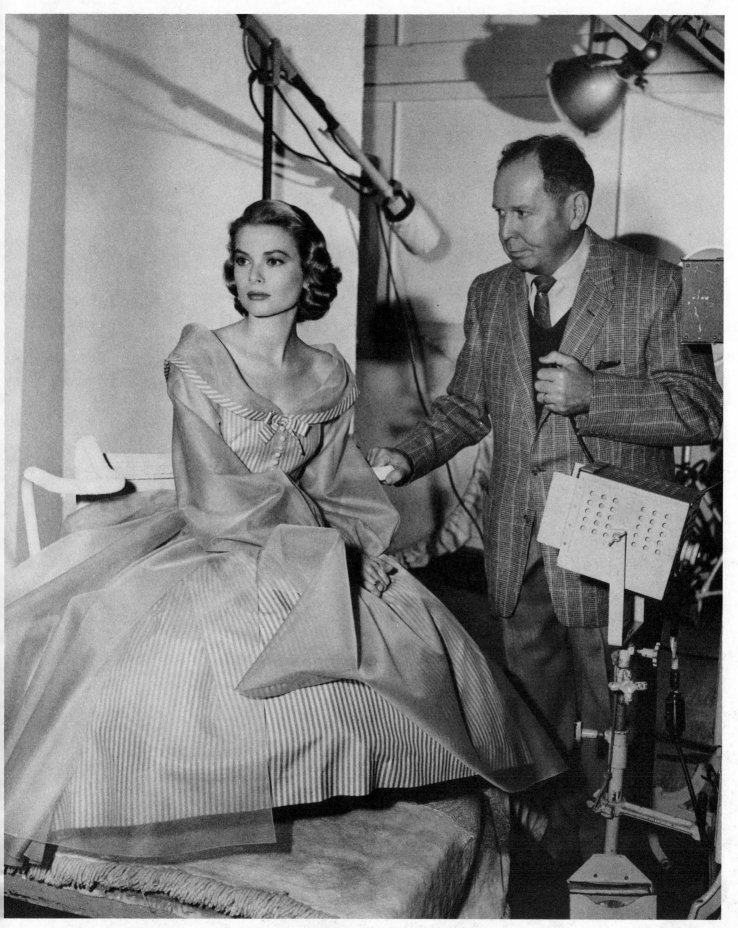

Grace Kelly and Clarence Bull

Grace Kelly (This portrait is on a Monaco stamp)

Madge Kennedy (1920)

Kathleen Key

Deborah Kerr (1947)

Pat Kirkwood

Otto Kruger

Bert Lahr (1931)

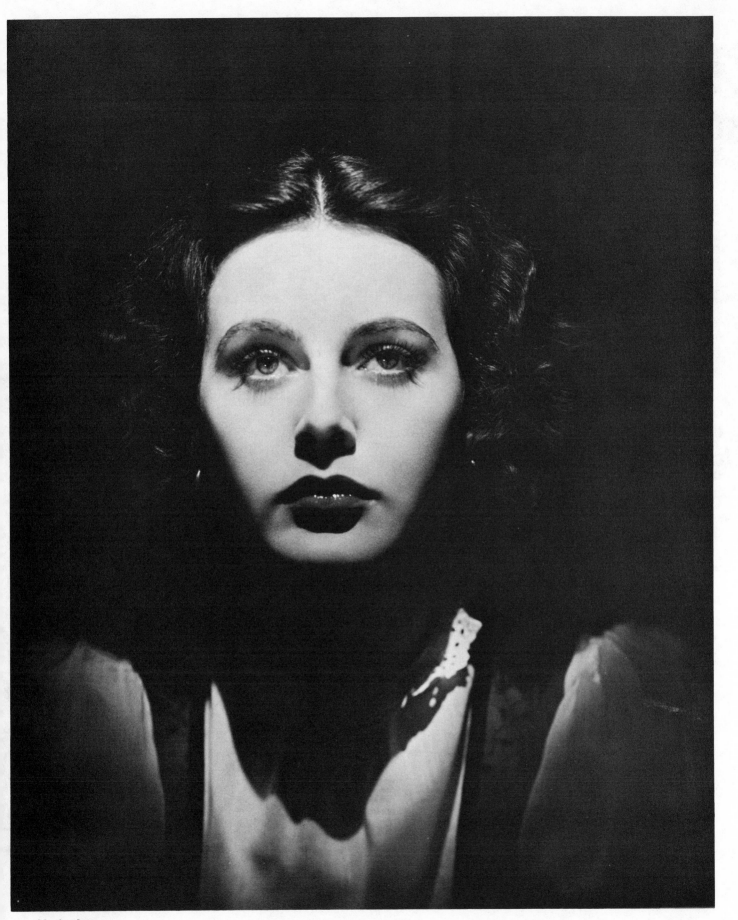

Hedy Lamarr

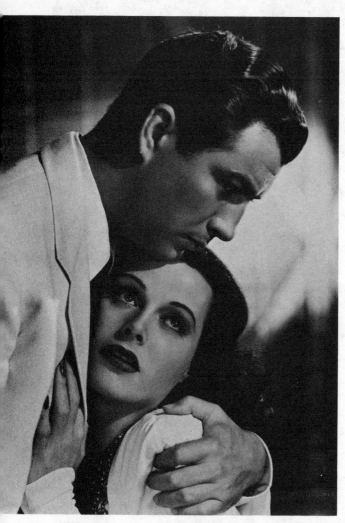

Hedy Lamarr and Robert Taylor

Hedy Lamarr

Cullen Landis

Frank Lawton

Charles Laughton

171

Barbara Lang

Laura La Plante

Angela Lansbury

Janet Leigh

Jacqueline Logan

Carole Lombard

Virginia Loomis

Don Loper

Ann Loring

Peter Lorre

Bessie Love

Myrna Loy

Paul Lukas

William Lundigan

Carol Lynley

Ben Lyon

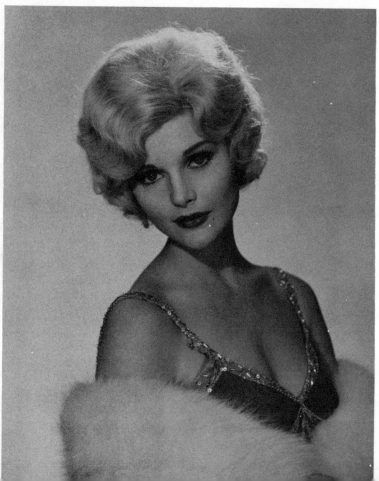

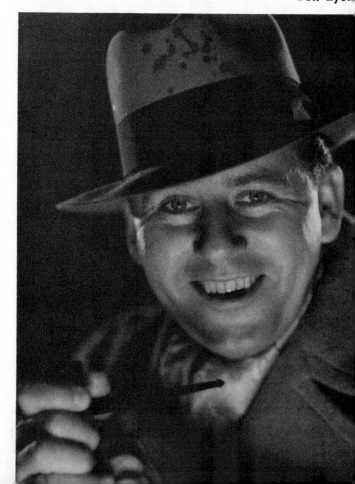

Tim McCoy

Jeanette MacDonald

Marie MacDonald

Molly Malone

Louis Mann

Fredric March

179

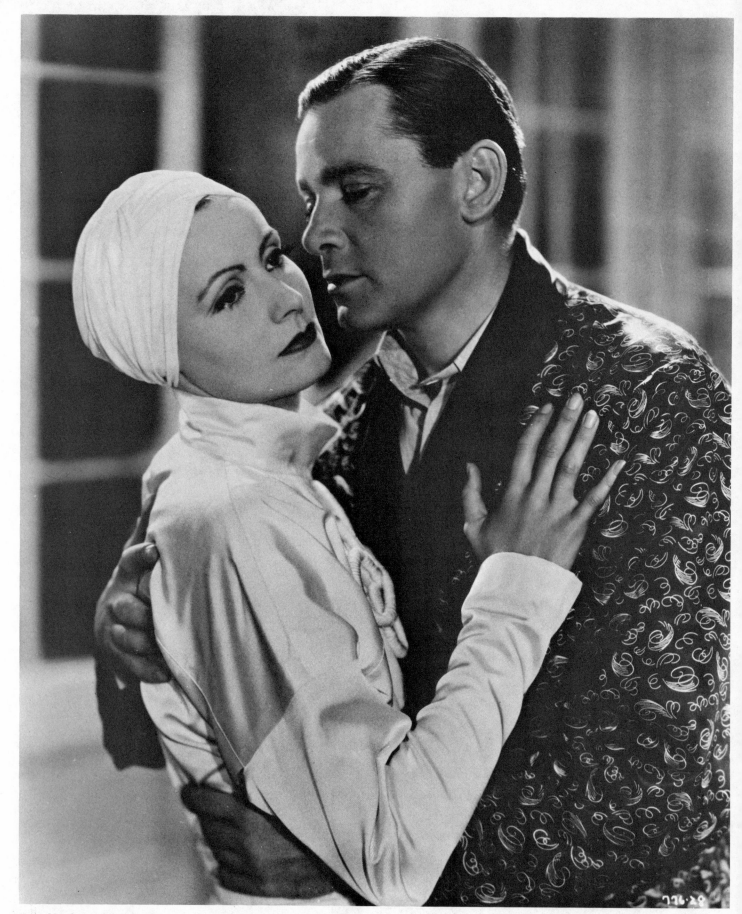

Herbert Marshall and Greta Garbo in
"The Painted Veil"

Herbert Marshall

Ilona Massey

Marilyn Maxwell

Patricia Medina

182

Adolphe Menjou (1931)

Verree Teasdale (Mrs. Menjou)

Una Merkel

Carmel Myers

John Miljan

Ann Miller

Patsy Ruth Miller

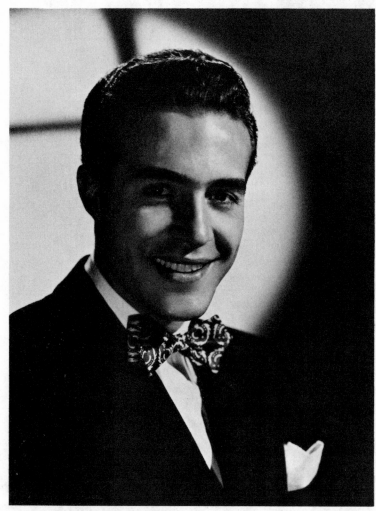

Ricardo Montalban

Robert Montgomery

Polly Moran

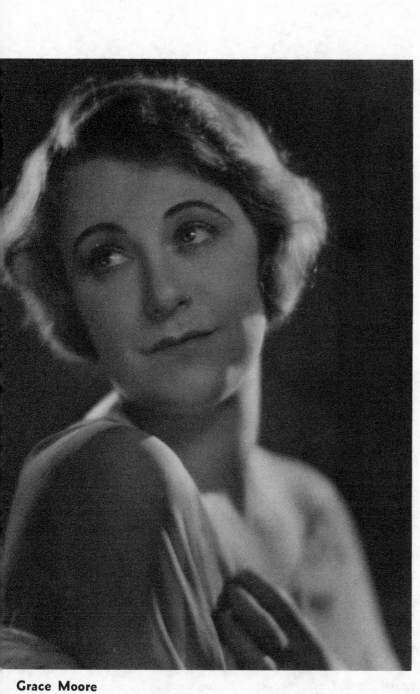

Grace Moore

Antonio Moreno

Frank Morgan

Karen Morley

Mae Murray as "The Merry Widow"

Dennis Morgan

Chester Morris

Conrad Nagel

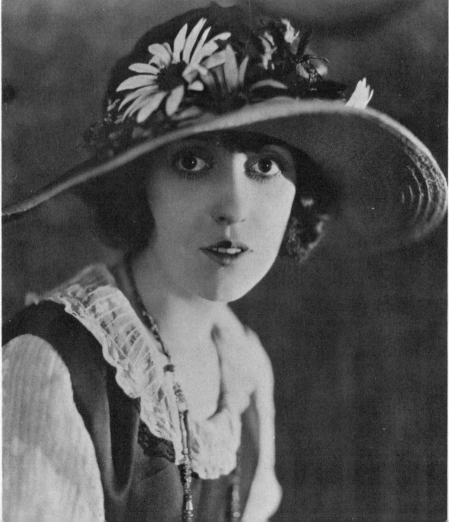

Mabel Normand

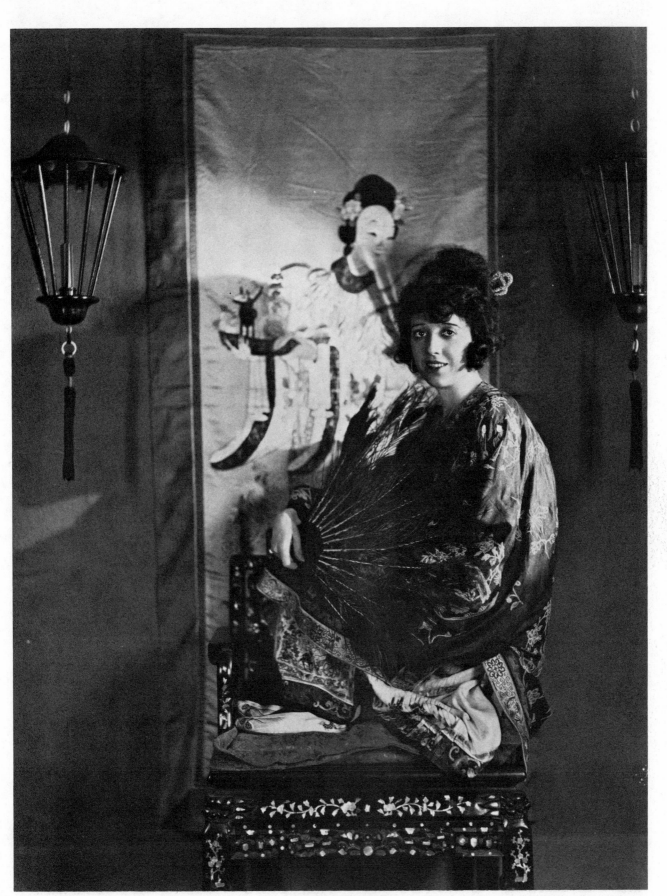

Mabel Normand

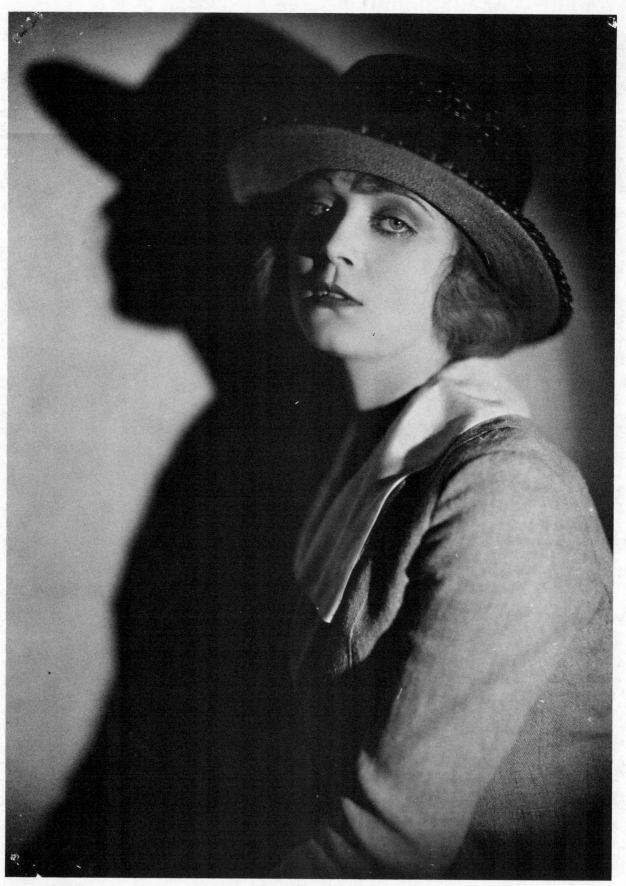

Jane Novak

Ramon Novarro

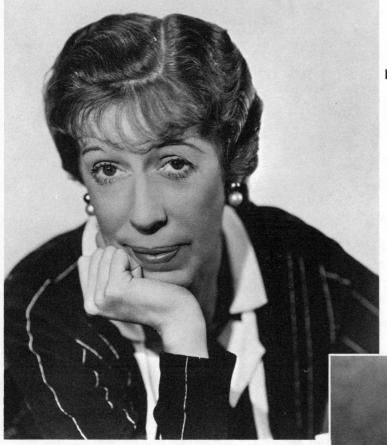

Edna May Oliver

Gertrude Olmstead

Margaret O'Brien

Sally O'Neil

Maureen O'Sullivan

198

Maureen O'Sullivan

Claire Owen

Anita Page

Reginald Owen

Andy Hardy's family: Left to right: Cecilia Parker, Mickey Rooney, Lewis Stone, Fay Holden, Sara Haden

Cecilia Parker

Eleanor Parker

202

Jean Parker

Walter Pidgeon

203

Ezio Pinza

Eleanor Powell

204

Jane Powell

William Powell

Aileen Pringle

Juanita Quigley

Frances Rafferty

Marjorie Rambeau

Luise Rainer

209

Donna Reed

Debbie Reynolds

Irene Rich

Irene Rich (1931)

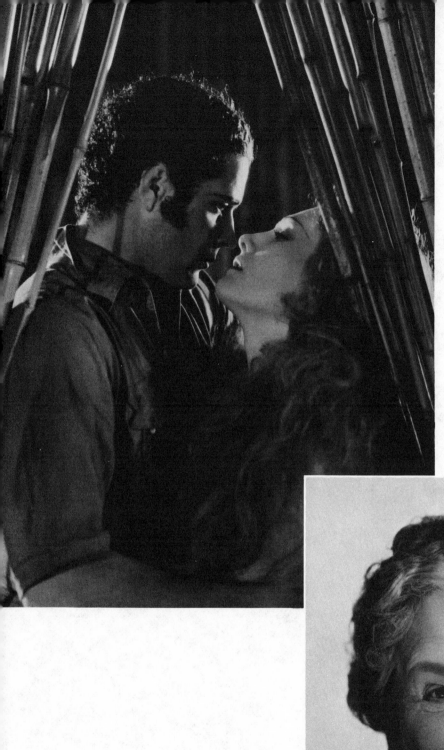

Duncan Renaldo and Edwina Booth in "Trader Horn"

May Robson

Ginger Rogers

Will Rogers

Will Rogers

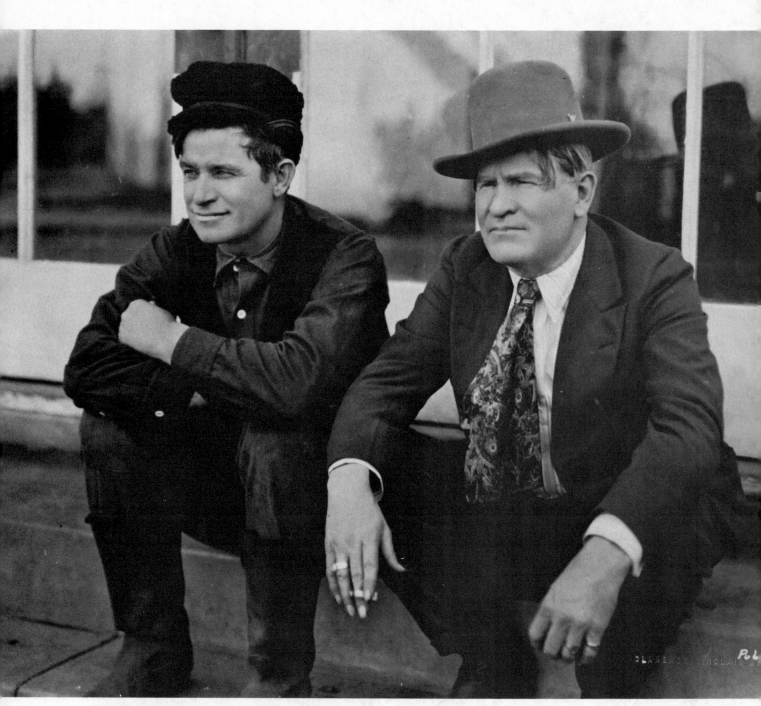

Will Rogers and Charles M. Russell, famous cowboy artist

Lina Romay

Mickey Rooney

Rosalind Russell

Ann Rutherford

Maria Schell

Mabel Julienne Scott (early 1920's)

Dorothy Sebastian

218

Ginny Simms ("Broadway Rhythm," 1943)

Sid Silvers

Russell Simpson

Alexis Smith

Ann Sothern

Pauline Starke

Vera Steadman

Eleanor Stewart

Lewis Stone

James Stewart

224

Margaret Sullavan

225

Blanche Sweet

Marian Tally

Elizabeth Taylor

229

Robert Taylor

Robert Taylor and Hedy Lamarr in "Lady of the Tropics"

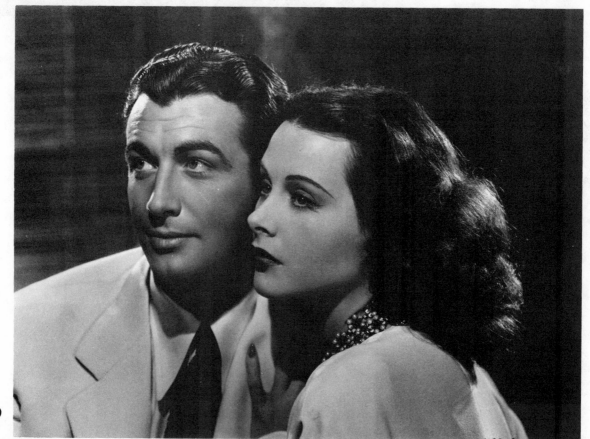

230

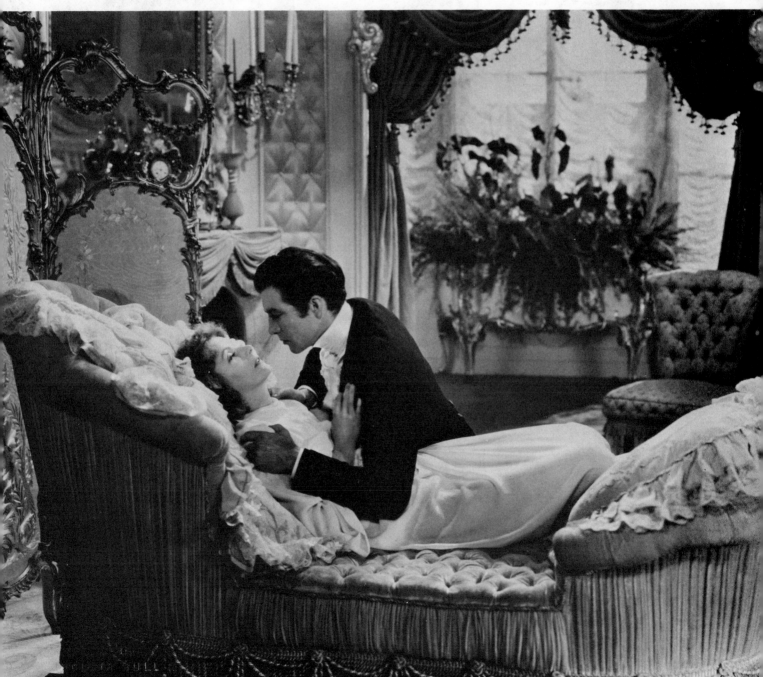

Robert Taylor and Greta Garbo in "Camille"

Lawrence Tibbett

Audrey Totter

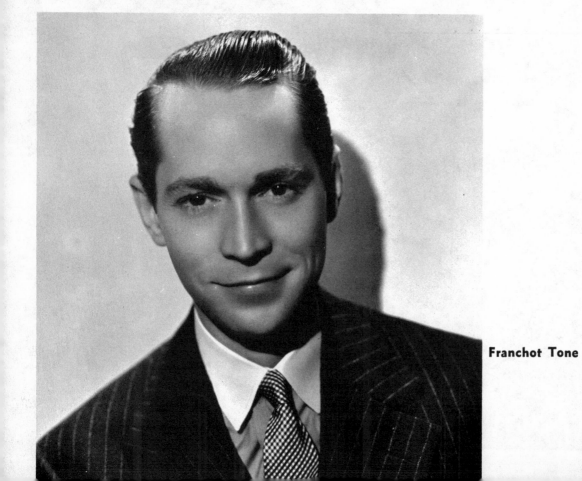

Franchot Tone

Spencer Tracy

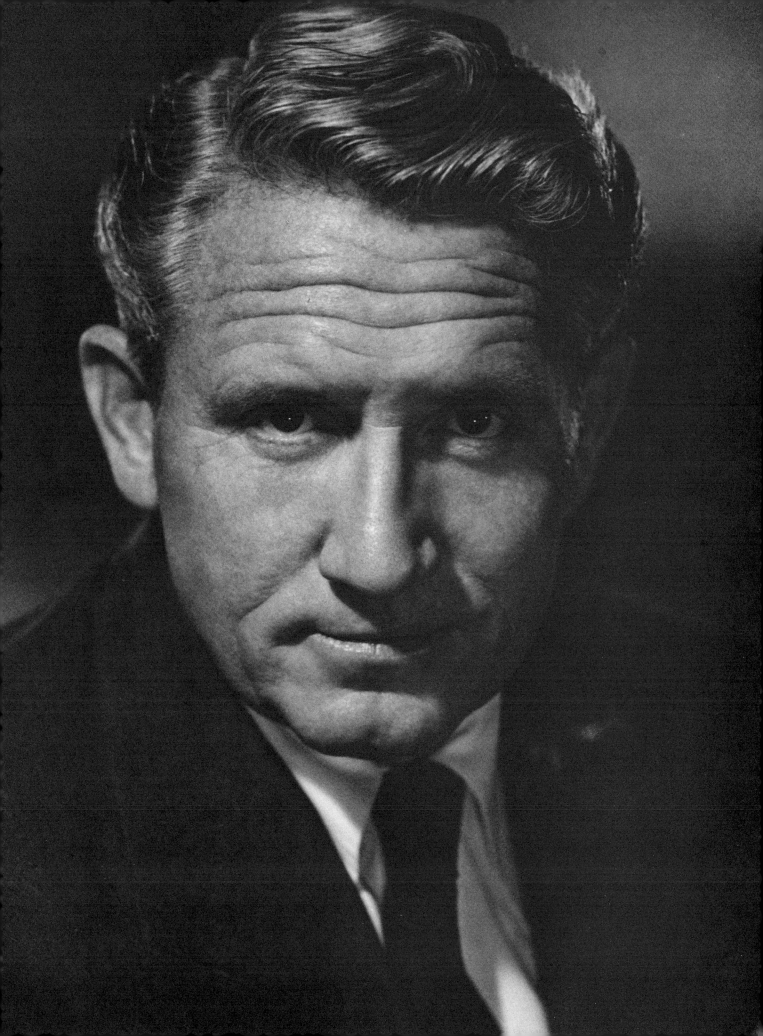

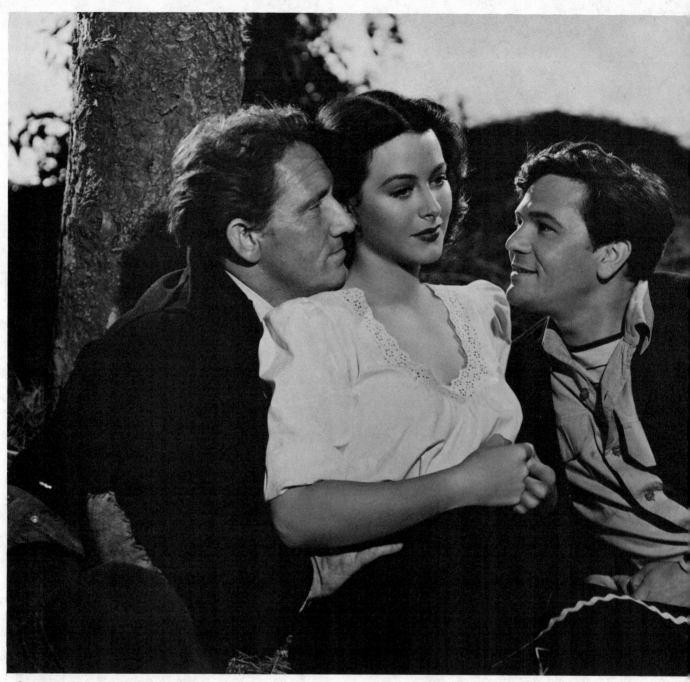

Spencer Tracy, Hedy Lamarr and John Gar-
field in "Tortilla Flat"

Spencer Tracy and Claudette Colbert

Spencer Tracy

235

Lana Turner

Charles Trowbridge

Helen Twelvetrees (1932)

Beverly Tyler

Lupe Velez

Virginia Valli

W. S. Van Dyke, director

Conrad Veidt

Robert Walker

Clifton Webb

Weber and Fields

Johnny Weissmuller

Esther Williams

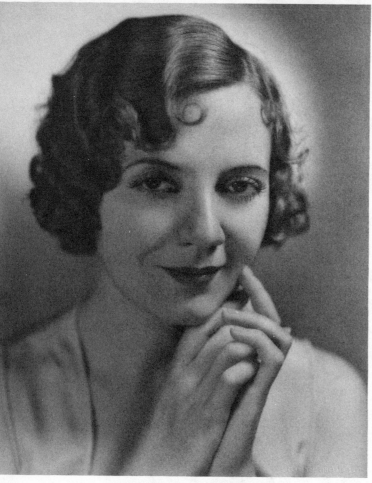

Lois Wilson (1932)

Claire Windsor

Anna May Wong (1930

Marie Windsor (1947)

Jane Wyman

Diana Wynyard

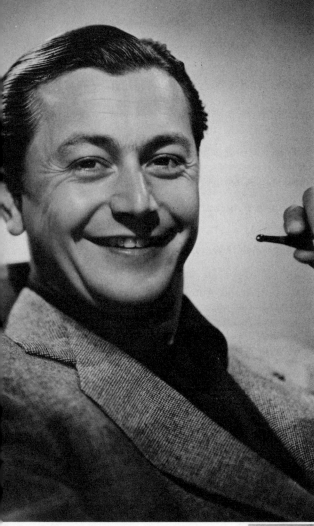

Robert Young

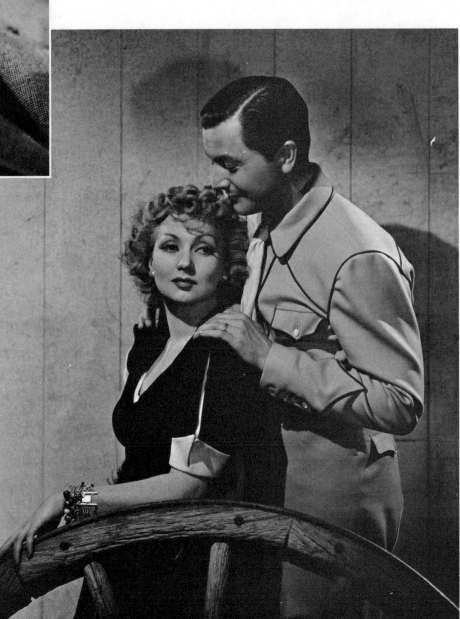

Robert Young and Ann Sothern

Technical Appendix

Page 14:
Subject—Pauline Fredrick
Director: Frank Lloyd, Clarence Bull
Light Source—Photo Flash Powder
Exposure—1/4 sec.
Lens—12-in. Goerz-Dagor
Stop—F:11
Negative—8x10 E.K. pan.
Neg. Developer—Borax-Elon
Print Dev.—D-72 type
Print Paper—Azo-matte Contact

Page 15–16:
Subject—Geraldine Farrar, Lou Tellegan, Pauline Fredrick
Light Source—Day lite
Exposure—1/50 sec.
Lens—8 1/2-in. Cooke
Stop—F:4.5
Negative—5x7
Neg. Dev.—Elon-Hydrochinone
Print Dev. D-72-Type
Print Paper—Azo-matte Contact

Page 18–20:
Subject—Gloria Swanson
Light Source—Incandescent spot and soft flood
Exposure—1/2 sec.
Lens—18-in. Cooke
Neg.—Portrait Pan
Neg. Dev.—D-76
Print Dev.—D-72
Print Paper—Velour Black (Enlarge)

Page 22:
Subject—Garbo
Light Source—Garbo—Incandescent spot and flood
Exposure—1/5 sec.
Lens—18-in. Cooke
Neg.—Portrait Pan
Neg. Dev.—D-76 (EK)
Print Dev.—55 D. (Dupont)
Print Paper—Velour Black

(Garbo original-vignetted against black velvet and re-exposed on photo of Sphinx. Face of Sphinx was air brushed blacked out before re-exposure.)

Page 24:
Subject—Greta Garbo and Marie Dressler
Light Source—Incandescent
Exposure—1/5 sec.
Lens—14-in. Goerz-Dagor
Stop—F:11
Neg.—Portrait Pan
Neg. Dev.—D-76
Print Dev.—D-72
Print Paper—Azo D.W. Gloss (EK)

Page 25:
Subject—Garbo
Light Source—Incandescent
Exposure—1 sec.
Lens—18 in. Cooke
Stop—F:11
Neg.—Portrait Pan (8x10)
Neg. Dev.—D-76
Print Dev.—D-72
Print Paper—Azo-D.W. matte (EK)

Page 26:
Subject—Garbo and Antonio Moreno
Light Source—Incandescent
Exposure—1/2 sec.
Lens—12-in. Goerz-Dagor
Neg.—Portrait Pan
Neg. Dev.—D-76
Print Dev.—D-72
Print Paper—Azo S.W.T. Gloss

Page 27:
Subject—Garbo
Light Source—Candle lite only
Exposure—10 sec.
Lens—18-in. Cooke
Stop—F:11
Neg.—Portrait Pan
Neg. Dev.—D-16
Print Dev.—55 D.
Print Paper—Velour Black

Pages 28–29–30:
Subject—Five Production Stills
Light Source—Incandescent
Exposure—1/5 sec. to 1/2 sec.
Lens—12-in. Goerz-Dagor
Stop—F:10
Neg.—Portrait Pan
Neg. Dev.—D-76
Print Dev.—D-72
Print Paper—Azo D.W.T. Gloss

Pages 33–34:
Subject—Renee Adoree, Coleen Moore
Light Source—Incandescent spots and flood fill
Exposure—1/2 sec.
Lens—14-in. Goerz
Stop—F:8
Negative—Par Speed Panchromatic (8x10)
Neg. Dev.—Borax Metol Hydrachinone (basic)
Print Paper—Artura (Defender)

Pages 36–38:
Subject—Norma Shearer
Light Source—Incandescent spots and flood fill
Exposure—1/2 sec.
Lens—18-in. Cooke

Stop—F:10
Neg.—Super XX E.K.
Neg. Dev.—D-76
Print Dev.—55 D.
Print Paper—Velour Black (Dupont)

Page 41:
Subject—Constance Bennett
Light Source—Incandescent spots and flood fill
Exposure—1/2 sec.
Lens—18-in. Cooke
Stop—F:10
Neg.—SuperXX E.K.
Neg. Dev.—D-76
Print Dev.—55 D.
Print Paper—Velour Black (Dupont)

Page 43:
Subject—John Barrymore, Diana Wynyard
Light Source—2 Incandescent spots and flood fill
Exposure—1/2 sec.
Lens—14 in. Goerz-Dagor
Stop—F:11
Neg.—Super XX Pan
Neg. Dev.—D-76
Print Dev.—55 D.
Print Paper—Velour Black (Dupont)

Page 44:
Subject—John Barrymore
Light Source—Incandescent black lights and flood fill
Exposure—1 sec.
Lens—14 in. Cooke
Stop—F:10
Neg.—Super XX Pan
Neg. Dev.—D-76
Print Dev.—55 D.
Print Paper—Velour Black

Page 46:
Subject—Greta Garbo
Light Source—3 Incandescent spots and flood fill
Exposure—1/2 sec.
Lens—14-in. Goerz-Dagor
Stop—F:11
Neg.—Super XX
Neg. Dev.—D-76
Print Dev.—D-72
Print Paper—Azo D. W.

Pages 48–49:
Subject—Lionel Barrymore
Light Source—Incandescent spot side lite and flood lite fill
Exposure—1 sec.
Lens—18-in. Cooke
Stop—F:12
Neg.—Super XX
Neg. Dev.—D-76
Print Dev.—55 D.
Print Paper—Velour Black

Page 50:
Subject—The Barrymores
Light Source—2 Incandescent spot back lites and flood fill
Exposure—1/2 sec.
Lens—14-in. Goerz-Dagor
Stop—F:8
Neg.—Super XX
Neg. Dev.—D-76
Print Dev.—55 D.
Print Paper—Velour Black Gloss

Page 52:
Subject—Ethel Barrymore
Light Source—Incandescent
Exposure—1/2 sec.
Lens—18-in. Cooke
Stop—F:11
Neg. Dev.—D. 76
Negative—Super XX
Print Paper—Velour Black

Pages 55–57:
Subject—Lon Chaney
Light Source—Incandescent
Exposure—1 sec.
Lens—14-in. Goerz-Dagor
Stop—F:11
Neg.—Portrait Pan
Neg. Dev.—Borax (Elon-Hydroquinone)
Print Dev.—Elon-Hydrochinone
Print Paper—P.M.C. Bromide (enlg.)

Pages 60–61:
Subject—Jeannette MacDonald—Nelson Eddy
Light Source—Incandescent
Exposure—1/2 sec.
Lens—18-in. Cooke
Neg.—Super XX
Neg. Dev.—D. 76
Print Dev.—55 D.
Print Paper—Velour Black

Page 62:
Subject—Clark Gable
Light Source—Incandescent
Exposure—1 sec.
Lens—18-in. Cooke
Stop—F:12
Neg.—Super XX
Neg. Dev.—D 76
Print Dev.—55-D.
Print Paper—Velour Black

Pages 64–67:
Subject—Clark Gable, Vivien Leigh, Clarence Bull
Light Source—Incandescent (long shots photo flash)
Exposure—for close ups 1-sec.
Lens—18-in. Cooke
Stop—F:10
Neg.—Super XX
Neg. Dev.—D. 76
Print Dev.—55 D.
Print Paper—Velour Black

Page 69:
Subject—Clark Gable—Hedy LaMarr
Light Source—Incandescent
Exposure—1 sec.
Lens—18-in. Cooke
Stop—F:12
Neg.—Super XX
Neg. Dev.—D-76
Print Dev.—55D.
Print Paper—Velour Black

Page 70:
Subject—Carole Lombard
Light Source—Incandescent
Exposure—1-sec.
Lens—14-in. Goerz-Dagor
Stop—F:11
Neg.—Super XX
Neg. Dev.—D-76
Print Dev.—D-72
Print Paper—Azo (double weight)

Pages 71–72–74:
Subject—Gable—Harlow
Light Source—Incandescent spot back lite and flood fill
Exposure—1/2 sec.
Lens—18-in. Cooke
Stop—F:10
Neg.—Super XX
Neg. Dev.—D-76
Print Dev.—55-D.
Print Paper—Velour Black

Pages 75–76:
Subject—Jean Harlow
Light Source—All Incandescents spot lights
Exposure—1/2-sec.
Lens—18-in. Cooke
Stop—F:10
Neg.—Super XX
Neg. Dev.—D-76
Print Dev.—55-D.
Print Paper—Velour Black

Page 80:
Subject—Elizabeth Taylor
Light Source—Incandescent
Exposure—1-sec.
Lens—18-in. Cooke
Stop—F:10
Neg.—Portrait Panchromatic
Neg. Dev.—Borax
Print Dev.—D-72
Print Paper—P.M.C. Bromide

Page 85:
Subject—Edie Adams—June Allyson—Elizabeth Allen
Light Source—Incandescent
Exposure—1-sec.
Lens—18-in. Cooke
Stop—F:10
Neg.—Super XX
Neg. Dev.—D-76

Print Dev.—55-D.
Print Paper—Velour Black

Page 89:
Subject—Lucille Ball
Light Source—Incandescent
Exposure—1 sec.
Lens—18-in. Cooke
Stop—F:11
Neg.—Super XX
Neg. Dev.—D-76
Print Dev.—55-D
Print Paper—Velour Black

Page 90:
Subject—Tallulah Bankhead
Light Source—Incandescent spot for key light and back light flood fill
Exposure—1/2 sec.
Lens—18-in. Cooke
Stop—F:10
Neg.—Super XX
Neg. Dev.—D-76
Print Dev.—D-72
Print Paper—Opal (G)

Page 92:
Subject—Freddie Bartholomew
Light Source—Incandescent bulb in lantern, weak spot light, illuminating his left cheek, and soft fill
Exposure—1/2-sec.
Lens—14-in. Goerz-Dagor
Stop—F:8
Neg.—Portrait Pan
Neg. Dev.—Borax
Print Dev.—D-72
Print Paper—Azo

Page 94:
Subject—Wallace Beery
Light Source—Incandescent
Exposure—1-sec.
Lens—18-in. Cooke
Stop—F:10
Neg.—Ortho Chromatic
Neg. Dev.—D-76
Print Dev.—55-D
Print Paper—Velour Black

Page 95:
Subject—Joan Bennett
Light Source—Incandescent spot for key light diffused-Incandescent spots for back lighting soft fill
Exposure—1 sec.
Lens—14-in. Goerz-Dagor
Stop—F:8
Neg.—Super XX
Neg. Dev.—D-76
Print Dev.—55-D
Print Paper—Velour Black

Pages 96–99:
Light Source—Incandescent spot lights and flood lights,

incandescent spot lights also used for back lights
Exposure—1 sec.
Lens—14-in. Goerz-Dagor
Stop—F:8
Neg.—Portrait Pan (8x10)
Neg. Dev.—Borax
Print *Dev.*—D-72 type
Print Paper—Azo matte

Page 100:
Subject—Edwina Booth
Light Source—Incandescent
Exposure—1/5 sec.
Lens—14-in. Cooke
Stop—F:8
Neg.—Par speed film
Neg. Dev.—Borax
Print Dev.—D-72 type
Print Paper—Azo-E-DW.

Page 101:
Subject—Hobart Bosworth
Light Source—Baby Arc in fireplace, shadow side illuminated
 by small arc spot diffused, some day light
Exposure—1 sec.
Lens—12-in. Goerz-Dagor
Stop—F:6.3
Neg.—Par speed film (ortho)
Neg. Dev.—Borax
Print Dev.—(no record)

Page 104:
Subject—Lorraine Bridges, Johnny Mac Brown, Virginia
 Bruce
Light Source—Incandescent
Lens—18-in. Cooke Bridges and Bruce, 12-in. Goerz-Brown
Neg.—Super XX Pam
Neg. Dev.—D-76 type
Print Dev.—D-72 and 55-D
Print Paper—Velour Black. Lower part of print of Brown
 dodged. In the under exposed area another neg. was
 used to print in football players.

Page 108:
Subject—Louis Calhern
Light Source—Incandescent
Exposure—1 sec.
Lens—18-in. Cooke
Stop—F:10
Neg.—Super XX (5x7)
Neg. Dev.—D-76
Print Dev.—55-D
Print Paper—Velour Black

Page 110:
Subject—Harry Carey, Leo Carillo
Light Source—Incandescent
Exposure—1 sec.
Lens—18-in. Cooke
Stop—F:10
Neg.—Port. Pan (8x10)
Neg. Dev.—D-76
Print Dev.—55-D

Print Paper—Velour Black

Page 111:
Subject—Mary Carlisle
Light Source—Incandescent
Exposure—1 sec.
Stop—F:11
Lens—18-in. Cooke
Neg—Super XX (5x7)
Neg. Dev.—D-76
Print Dev.—55-D
Print Paper—Velour Black

Page 112:
Subject—Leslie Caron
Light Source—Ascor Strobe Lights
Exposure (approx.)—1/1000-sec.
Lens—18-in. Cooke
Stop—F:11
Neg.—Super XX (5x7)
Neg. Dev.—D-76
Print Dev.—55-D
Print Paper—Varigan—DL

Page 113:
Subject—Castleton-Chadwick
Light Source—Arc spot lights Cooper-Hewitt
Exposure—2 sec.
Lens—14-in. Goerz-Dagor
Stop—F:8
Neg.—Par speed film (ortho)
Neg. Dev.—Borax
Print Dev.—D-72-type
Print Paper—Azo matte

Page 114:
Subject—Cyd Charisse
Light Source—Strobe Lights
Exposure—approx. 1/1000
Lens—Close-ups 18-in. Cooke
Stop—F:11
Neg.—Super XX
Neg. Dev.—D-76
Print Dev.—55-D
Print Paper—Velour Black (Varigan)
 Lighting on close-ups was accomplished by the use of
 "snoots" and bounce light from two other strobes. Dance
 scene was also made by strobe using 12-in. Dagor. Ex-
 posure approx. 1/1000 sec. Original was an ektachrome
 transparency from which a black and white negative was
 made from that neg. black and white print.

Page 116:
Subject—Maurice Chevalier, Naomi Childers
Light Source—Incandescent
Exposure—Chevalier—1/2 sec., Childers—1 sec.
Lens—18-in. Cooke
Neg.—Portrait Pan
Neg. Dev.—D-76
Print Dev.—D-72
Print Paper—Velour Black—DL

Page 117:
Subject—Claudette Colbert—Clark Gable
Light Source—Incandescent
Exposure—1/2 sec.
Lens—14-in. Goerz-Dagor
Stop—F:8
Neg.—Super XX
Neg. Dev.—D-76
Print Dev.—D-72
Print Paper—Azo (SWG)

Page 118:
Subject—Jackie Cooper (1931–1932) and Ricardo Cortez
Light Source—Incandescent
Exposure—1/2 sec.
Lens—14-in. Goerz-Dagor
Stop—F:8
Neg.—Portrait Pan
Neg. Dev.—Borax Metol
Print Dev.—D-72-type
Print Paper—Azo

Page 119:
Subject—Crane, Gillingwater, Francis
Light Source—Arc lites
Exposure—1/2 sec.
Lens—12-in. Goerz-Dagor
Stop—F:8
Negative—Portrait Pan
Neg. Developer—Borax Metol
Print Dev.—D-72-type, with metol
Print Paper—Azo

Page 120:
Subject—Joan Crawford
Light Source—Arc lites
Exposure—1/2 sec.
Lens—12-in. Goerz-Dagor
Stop—F:7.7
Neg.—Portrait Film—EK
Neg. Developer—Borax Metol
Print Dev.—D-72-type
Print Paper—Azo

Page 121:
Subject—Joan Crawford
Light Source—Incandescent
Exposure—1 sec.
Lens—18-in. Cooke
Stop—F:11
Neg.—Super XX
Neg. Developer—D-76
Print Dev.—D-72
Print Paper—Velour Black

Page 122:
Subject—Arlene Dahl
Light Source—Incandescent
Exposure—1 sec.
Lens—18-in. Cooke
Stop—F:11
Neg.—Super XX
Neg. Developer—D-76

Print Dev.—55-D
Print Paper—Varigan DL

Page 123:
Subject—Lili Damita—Viola Dana
Light Source—Arcs and Cooper Hewett
Exposure—1/2 sec.
Lens—14-in. Goerz-Dagor
Stop—F:8
Neg.—Portrait Pan
Neg. Developer—Metol—Hydroquinone
Print Dev.—D-72-type
Print Paper—Velour Black

Page 124:
Subject—Marion Davies
Light Source—Incandescent
Exposure—1/2 sec.
Lens—18-in. Cooke
Stop—F:10
Neg.—Super XX
Neg. Dev.—D-76
Print Dev.—Borax Metol
Print Paper—Velour Black

Page 124:
Subject—Nancy Davis (Mrs. Ronald Reagan)
Light Source—Incandescent
Exposure—1 sec.
Lens—18-in. Cooke
Stop—F:11
Neg.—Super XX
Neg. Dev.—D-76
Print Dev.—D-72
Print Paper—Varigan-DL

Page 127:
Subject—Marlene Dietrich
Light Source—Incandescent
Exposure—1 sec.
Lens—14-in. Goerz-Dagor
Stop—F:8
Neg.—Super XX (slight diffusion)
Neg. Dev.—D-76
Print Dev.—55-D
Print Paper—Velour Black-DL

Page 130:
Subject—Marie Dressler, Mary Duncan, Irene Dunne, Jimmie Durante
Light Source—Incandescent
Exposure—1/2 sec. (Dressler-Duncan-Durante) 1 sec. (Irene Dunn)
Lens—18-in. Cooke
Stop—F:10 (Dunn—F:11)
Neg.—Super XX
Neg. Dev.—D-76
Print Dev.—D-72
Print Paper—Velour Black-DL

Page 133:
Subject—Madge Evans, Louise Fazenda
Light Source—Incandescent

Exposure—1 sec.
Lens—Goerz-Dagor 19-in. Stop—F:8
Neg.—Super XX
Neg. Developer—D-76
Print Dev.—D-72
Print Paper—Velour Black-DL

Page 134:
Subject—Alec B. Francis
Light Source—Arc and Cooper Hewett
Exposure—1/2-sec.
Lens—Goerz-Dagor 12-in.
Stop—F:8
Negative—Ortho Chromatic Film
Neg. Developer—Borax Metol type
Print Dev.—Metol Hydroquinone
Print Paper—Velour Black

Page 137:
Subject—Ava Gardner, Judy Garland
Light Source—Incandescent
Exposure—1 sec.
Lens—18-in. Cooke
Stop—F: 11
Negative—Super XX
Neg. Developer—D-76
Print Dev.—D-72
Print Paper—Velour Black DL

Page 138:
Subject—Greer Garson
Light Source—Incandescent—spot lites and soft fill
Lens—18-in. Cooke
Stop—F:10
Negative—Super XX
Neg. Developer—D-76
Print Dev.—D-72
Print Paper—Velour Black-DL

Page 139:
Subject—Frances Gifford
Light Source—Incandescent—spot lite and soft fill
Exposure—1 sec.
Lens—18-in. Cooke
Stop—F: 11
Neg.—Super XX
Neg. Dev.—D-76
Print Dev.—D-72
Print Paper—Velour Black
 (Back lighting by inky spots. Key lite—also inky spot with very slight diffusion. Soft flood fill light. Background lighted separately.

Page 144:
Subject—Corinne Griffith, Virginia Grey
Light Source—Incandescent
Exposure—1 sec.
Lens—14-in. Goerz-Dagor (Griffith), 18-in. Cooke (Grey)
Stop—F:8, F:10
Neg.—Portrait Pan
Neg. Dev.—Borax Elon (Elon Borax type)
Print Dev.—D-72
Print Paper—Velour Black

Page 146:
Subject—Ann Harding
Light Source—Incandescent
Exposure—1 sec.
Lens—18-in. Cooke
Stop—F:10
Negative—Portrait Pan
Neg. Developer—Elon Borax
Print Dev.—D-72
Print Paper—Velour Black DL

Page 152-153:
Subject—Katharine Hepburn
Light Source—Incandescent
Exposure—1 sec.
Lens—18-in. Cooke
Stop—F:11
Negative—Super XX
Neg. Developer—D-76
Print Dev.—D-72
Print Paper—Velour Black DL

Page 155:
Subject—Leslie Howard, Norma Shearer
Light Source—Incandescent
Exposure—1/2 sec.
Lens—18-in. Cooke
Stop—F:11
Neg.—Super XX
Neg. Dev.—D-76
Print Dev.—55-D
Print Paper—Varigan

Page 158:
Subject—Dorothy Jordan
Light Source—Incandescent
Exposure—1/2 sec.
Lens—19-in. Goerz-Dagor
Stop—F:7.7
Neg.—Portrait Pan
Neg. Dev.—Elon Borax
Print Dev.—D-72-type
Print Paper—Velour Black-DL
 (Wind blown effect obtained by subject leaning over back of chair.)

Page 159:
Subject—Louis Jourdan, Leslie Caron, Maurice Chevalier
Light Source—Strobe
Exposure—Approx. 1/1000 sec.
Lens—14-in. Goerz-Dagor
Stop—F:16
Neg.—Super XX
Neg. Dev.—D-76
Print Dev.—55-D
Print Paper—Varigan-DL

Page 160:
Subject—Leatrice Joy
Light Source—Arc—Cooper Hewett and day lite
Exposure—2 sec.
Lens—13½ in. Cooke
Stop—F:8

Neg. Dev.—Metol Borax
Print Dev.—M.Q.
Print Paper—Azo

Pages 164–165:
Subject—Grace Kelly
Light Source—Strobe
Exposure—1/1000 sec.
Lens—18-in. Cooke
Stop—F:16
Neg.—Super XX
Neg. Dev.—D-76
Print Dev.—D-72
Print Paper—Varigan DL

Page 166:
Subject—Madge Kennedy
Light Source—Arc lite and day lite
Exposure—Approx. 1-sec.
Lens—13½-in. Cooke
Stop—F:8
Neg.—Power speed portrait film

Pages 169–170:
Subject—Hedy LaMarr
Light Source—Incandescent
Exposure—½-sec.
Lens—18-in. Goerz-Dagor
Stop—F:10
Neg.—(8 x 10) Super XX
Neg. Dev.—D-76
Print Dev.—D-72
Print Paper—Varigan

Page 172:
Subject—Barbara Lang, Laura LaPlante, Angela Lansbury
Light Source—Incandescent
Exposure—Approx. ½-sec.
Lens—18-in. Cooke
Stop—F:11
Neg.—Super XX
Neg. Dev.—D-76
Print Dev.—D-72
Print Paper—Velour Black

Page 173:
Subject—Janet Leigh, Carole Lombard
Light Source—Incandescent
Exposure—1 sec.
Lens—(Leigh) 18-in. Cooke, (Lombard) 14-in. Goerz-Dagor
Stop—F:10, F:8
Neg.—Super XX
Neg. Dev.—D-76
Print Dev.—D-72
Print Paper—Velour Black

Page 173:
Subject—Jacqueline Logan
Light Source—Arc spot—Cooper Hewett and day lite fill
Exposure—2 sec.
Lens—14-in. Goerz Dagor
Stop—F:8

Neg.—Portrait Pan
Neg. Dev.—Metol Borax type

Page 178:
Subject—Jeannette MacDonald, Marie MacDonald, Molly Malone
Light Source—Incandescent
Exposure—1 sec.
Lens—18-in. Cooke (Molly Malone—14-in. Goerz Dagor)
Neg.—Super XX (both MacDonalds)
Neg. Dev.—D-76
Print Paper—Velour Black (Malone), Azo, Contact

Page 182:
Subject—Marilyn Maxwell, Patricia Medina
Light Source—Incandescent—spot lites—soft fill
Exposure—½ sec.
Lens—19-in. Cooke
Stop—F:11
Neg.—Super XX
Neg. Dev.—D-76—at 70 F
Print Dev.—D-72
Print Paper—Velour Black

Page 184:
Subject—Carmel Myers
Light Source—day lite
Exposure—3 sec.
Lens—13½-in. Cooke
Stop—F:5.6
Negative—Commercial Film

Page 188:
Subject—Antonio Moreno
Light Source—Arc and day lite fill
Exposure—1 sec.
Lens—12-in. Goerz-Dagor
Stop—F:5.6
Negative—Portrait Film

Page 191:
Subject—Mae Murray
Light Source—Arcs (made on set) no further record

Pages 192–193:
Subject—Mabel Normand
Light Source—Arc spots—Cooper Hewett and day lite fill
Exposure—2 sec.
Lens—14-in. Goerz-Dagor
Negative—Commercial

Page 196:
Subject—Margaret O'Brien
Light Source—Incandescent
Exposure—1 sec.
Lens—18-in. Cooke
Negative—Super XX
Negative Dev.—D-76
Print Dev.—D-72
Print Paper—Velour Black

Page 198:
Subject—Salley O'Neil

Light Source—Daylite
Exposure—1/2 sec.
Lens—12-in. Goerz-Dagor
Stop—F:5.6

Page 198:
Subject—Maureen O'Sullivan
Light Source—Incandescent
Exposure—1 sec.
Lens—18-in. Cooke
Stop—F:10
Neg.—Super XX
Neg. Dev.—D-76
Print Dev.—D-72

Page 202, 203:
Subject—Cecilia Parker, Eleanor Parker, Jean Parker
Light Source—Incandescent
Exposure—1 sec.
Lens—18-in. Cooke
Neg.—Super XX
Neg. Dev.—D-76
Print Dev.—D-72
Print Paper—Velour Black

Page 209:
Subject—Luise Rainer
Light Source—Incandescent
Exposure—1 sec.
Lens—18-in. Cooke
Stop—F:11
Neg.—Super XX
Neg. Dev.—D-76
Print Dev.—D-72
Print Paper—Velour Black DL

Page 210:
Subject—Irene Rich
Light Source—Incandescent—spot lites and soft fill
Exposure—1 sec.
Lens—19-in. Goerz-Dagor
Stop—F:8
Neg.—Portrait Pan
Neg. Dev.—Metol Borax type
Print Dev.—D-72
Print Paper—Velour Black

Pages 212, 213:
Subject—Ginger Rogers, Will Rogers
Light Source—Incandescent
Exposure—Approx. 1/2 sec.
Lens—18-in. Cooke
Stop—F:10
Negative—Super XX
Negative Dev.—D-76
Print Dev.—D-72 type
Print Paper—Will Rogers (Azo-Matte) Ginger Rogers
 (Velour Black)

Page 215:
Subject—Mickey Rooney
Light Source—Incandescent
Exposure—1 sec.

Lens—14-in. Goerz-Dagor
Stop—F:8
Neg.—Portrait Pan
Neg. Dev.—D-76
Print Dev.—D-72

Page 219:
Subject—Ginny Simms
Light Source—Incandescent
Exposure—1 sec.
Lens—14-in. Goerz-Dagor
Stop—F:8
Neg.—Portrait Pan
Neg. Dev.—D-76
Print Dev.—D-72
Print Paper—Velour Black

Page 220:
Subject—Russell Simpson
Light Source—Incandescent and Oil Lamp
Exposure—5 sec.
Lens—12-in. Goerz-Dagor
Print Dev.—D-72 type
Print Paper—Azo

Page 221:
Subject—Frank Sinatra
Light Source—Incandescent
Exposure—1 sec.
Lens—18-in. Cooke
Stop—F:10
Neg.—Super XX
Neg. Dev.—D-76
Print Dev.—D-72
Print Paper—Velour Black

Page 224:
Subject—Lewis Stone, James Stewart
Light Source—Incandescent
Exposure—1 sec.
Lens—18-in. Cooke (Lewis Stone) 14-in. Goerz-Dagor
 (James Stewart)
Neg.—Portrait Pan
Neg. Dev.—D-76
Print Dev.—D-72

Page 225:
Subject—Margaret Sullavan
Light Source—All lites Incandescent
Exposure—1 sec.
Lens—18-in. Cooke
Stop—F:10
Neg.—Portrait Pan
Neg. Dev.—D-76
Print Dev.—D-72
Print Paper—Velour Black

Page 227:
Subject—Elizabeth Taylor
Light Source—Incandescent
Exposure—1 sec.
Lens—18-in. Cooke
Stop—F:11

Negative—Super XX
Neg. Dev.—D-76
Print Dev.—D-72

Page 228:
Subject—Elizabeth Taylor
Light Source—Incandescent
Exposure—(upper) 1 sec.
Neg.—Super XX
Neg.—for lower photo, Super XX—35MM—Exposure 1/50 sec.
Neg. Dev.—for both—D-76
Print Dev.—D-72
Print Paper—Velour Black

Page 229:
Subject—Elizabeth Taylor
Black and White negative was duped from a dye-transfer color print. The original transparency was an (8 x 10) Ektachrome type B, made by photo flash.

Page 233:
Subject—Spencer Tracy
Light Source—Incandescent
Exposure—1 sec.
Lens—18-in. Cooke
Stop—F:11
Negative—Super XX
Negative Dev.—D-76
Print Dev.—D-72
Print Paper—Velour Black

Page 235:
Subject—Spencer Tracy, Claudette Colbert—Tracy
Light Source—Incandescent
Exposure—1 sec.
Lens—18-in. Cooke (Spencer Tracy), 14-in. Goerz-Dagor (Tracy and Colbert)
Stop—F:10
Negative—Super XX
Neg. Dev.—D-76
Print Dev.—D-72
Print Paper—Velour Black

Page 236:
Subject—Lana Turner
Light Source—Upper left—Incandescent
Exposure—1 sec. on Super XX. Upper right and lower—lite source is Strobe, Stop—F:16. All three are on Super XX
Neg. Dev.—D-76
Print Dev.—D-72
Print Paper—Velour Black

On two pictures with Strobe lites modeling was accomplished by lite bounced back from over head and front lites by bright reflectors.

Page 238:
Subject—Lupe Velez
Light Source—Arc spot and Cooper Hewett fill lite
Lens—12-in. Goerz-Dagor

Page 245:
Subject—Anna May Wong
Light Source—Incandescent
Exposure—1 sec.
Lens—14-in. Goerz-Dagor
Stop—F:8
Neg.—Portrait Pan
Neg. Dev.—D-76
Print Dev.—D-72
Print Paper—Velour Black

Most Reliable Formulas

Developer D-72

Avoirdupois

Water, about 125F	16 ounces
Elon Developing Agent	45 grains
Sodium Sulfite, desiccated	1½ ounces
Hydroquinone	175 grains
Sodium Carbonate, monohydrated	2 oz. 290 grains
Potassium Bromide	30 grains
Water to make	32 ounces

Dissolve chemicals in the order given. Use at 68°F
Keeping Properties—D-72, Gallon Tank, two weeks

Developer D-76 or Metol Borax
Developer D-76 is unsurpassed by any other developer in ordinary use for its ability to give full emulsion speed and maximum shadow detail with normal contrast. It produces moderately fine grain, has excellent development latitude, and produces relatively low fog on forced development. D-76 has long been a favorite of pictorial photographers.

Avoirdupois

Water, about 125F	24 ounces
Elon Developing Agent	30 grains
Sodium Sulfite, desiccated	3 oz. 145 grains
Hydroquinone	75 grains
Borax, granular C.P.	30 grains
Water to make	32 ounces

Dissolve chemicals in the order given.
Average development time, about 12 minutes at 68F
Keeping Properties—D-76, Gallon Tank, two weeks